The Art of
THEOREM
PAINTING

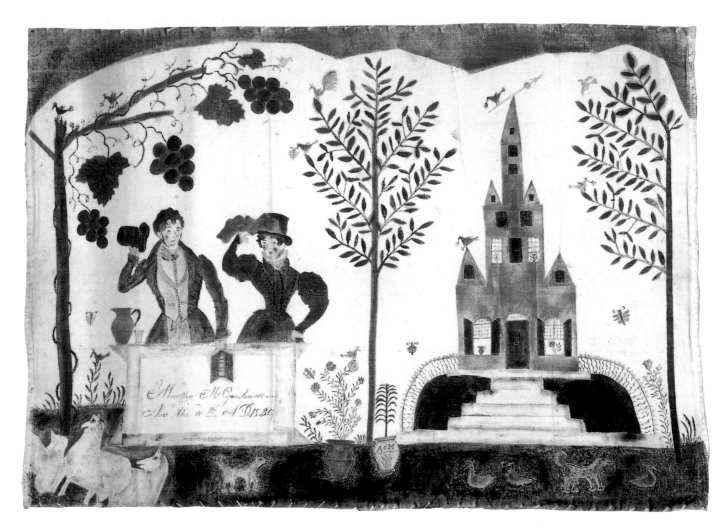

1. Dated 1830 on the front of the rostrum, this fascinating and important painting on velvet, which combines theorem and freehand techniques, is clearly by the same artist that created the velvet called *Morgan Addressing His Friends* in the collection of the Abby Aldrich Rockefeller Folk Art Center, Williamsburg, Virginia. Both velvets portray Charles Spencer Morgan of Virginia making a political speech—he was famous for his skill as an orator. 16″ x 22½″. (America Hurrah Antiques, N.Y.C.)

The Art of
THEOREM PAINTING

A History and

Complete Instruction Manual

Linda Carter Lefko

and

Barbara Knickerbocker

VIKING STUDIO BOOKS

TO THE READER

The authors and the publisher of this book bear no responsibility for any physical injury, destruction of property, or any other loss, damage, liability, or claim resulting from the use of products recommended or mentioned in this book, whether used properly or improperly.

VIKING STUDIO BOOKS

Published by the Penguin Group
Penguin Books USA Inc., 375 Hudson Street,
New York, New York, 10014, U.S.A.

Penguin Books Ltd, 27 Wrights Lane,
London W8 5TZ, England

Penguin Books Australia Ltd, Ringwood,
Victoria, Australia

Penguin Books Canada Ltd, 2801 John Street,
Markham, Ontario, Canada L3R 1B4

Penguin Books (N.Z.) Ltd, 182-90 Wairau Road,
Auckland 10, New Zealand

Penguin Books Ltd, Registered Offices:
Harmondsworth, Middlesex, England

First published by Viking Studio Books, an imprint of Penguin Books USA Inc.

First printing, October, 1994
10 9 8 7 6 5 4 3 2 1

Library of Congress
Catalog Card Number: 94-60775

Printed and bound by Dai Nippon Printing Co., Hong Kong, Ltd.

ISBN: 0-525-48596-1

We dedicate this book to Jessica Bond, Madeline Hampton, Gina Martin, and Emilie Underhill—all members of The Historical Society of Early American Decoration Inc.—for their contributions to the revival of knowledge and interest in theorem painting as a part of our American folk-art heritage.

Acknowledgments

We would like to give special thanks to the following members of The Historical Society of Early American Decoration, who generously contributed their original theorems for reproduction in the pattern section of this book: Helene Britt, Mary Jane Clark, Inez Gornall Cloward, Ruth Flowers, Doris Fry, Cornelia Keegan, Carol Loveland, Sally Lovely, Willie J. McLean, Jean S. Milonas, Mary Sanford, Helen Spear, Sara Tiffany, and Martha Wilbur.

Grateful acknowledgment is also made to the following individuals, shops, galleries, and institutions for providing material reproduced in this book or for their help in its formulation: Abby Aldrich Rockefeller Folk Art Center, Williamsburg, Virginia; Jane Bolster; Mr. and Mrs. Edwin Braman; Margaret Coffin; Sherry Dotter; Jean Gearin; Dorothy Hamblett; Michael Haskins Antiques, Palmyra, New York; D. and E. Howe; Joel and Kate Kopp, America Hurrah Antiques, New York City; Landmark Society of Western New York, Rochester, New York; Gina Martin; Cyril I. Nelson; Frank and Barbara Pollack, Highland Park, Illinois; Cynthia Stone; and the Western Reserve Historical Society, Cleveland, Ohio.

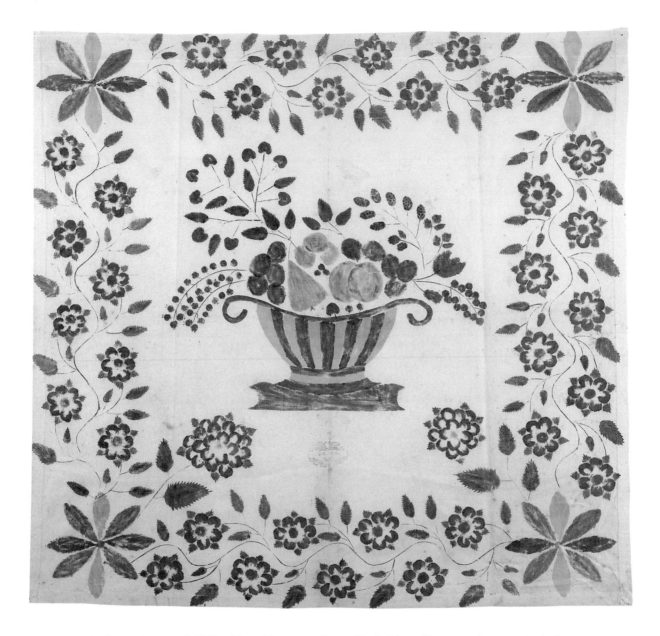

2. Created around 1835, this table cover from Tunbridge, Vermont, is a particularly charming example of early stenciling on fabric. (Frank & Barbara Pollack, Highland Park, Illinois)

Contents

3. It is unusual to find an oval theorem, and this is a handsome
example. Note the frilly cloth on which the fruit is arranged.
11″ x 21″. (America Hurrah Antiques, N.Y.C.)

Preface

As members of the Historical Society of Early American Decoration (H.S.E.A.D.) we have been asked many questions about the art of theorem painting on velvet over the years: "Where can I get patterns?," "How was it done in the past?," "Where can I get supplies?," and "Who can teach me how to make theorems?" In trying to answer these questions we have drawn from the research done by members of the H.S.E.A.D. and from theorems both in private collections and from those in the H.S.E.A.D. theorem collection. The chief purpose of this book is to provide a collection of authentic patterns for theorem painting on velvet and on paper, together with instructions on how to execute them.

Many articles have been written on the subject of painting theorems. Over the years we have tried a variety of tips, techniques, and materials. The methods outlined in this book aren't the only ways to paint a theorem on velvet, but simply what we have found works best for us. We have attempted to put this information in a form that is both educational and instructional. By including a history of the subject during the past two hundred years together with authentic patterns, we are attempting to provide the creative public with an updated art-instruction manual in the same spirit of those that first introduced the subject many years ago.

<div align="right">

LINDA CARTER LEFKO
BARBARA KNICKERBOCKER

</div>

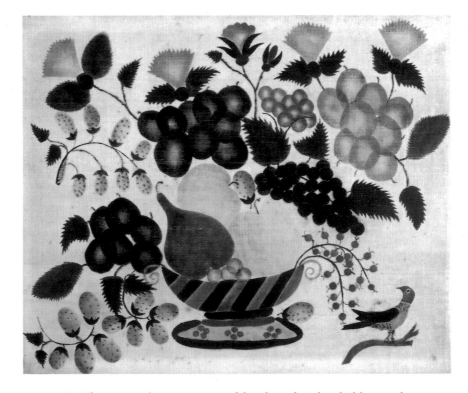

4. This tiny velvet is a gem of bright color that holds together the loosely arranged composition. 8″ x 11¼″. (America Hurrah Antiques, N.Y.C.)

A History of Theorem Painting

The art of embroidering needlework pictures became very popular in the first half of the eighteenth century, and such embroidery was considered an essential skill for young ladies to learn in order to beautify their homes. The female seminaries that were established to educate and "refine" young women included it in their curricula. Toward the end of the eighteenth century painted faces and backgrounds were being combined with embroidery. These pictures were usually done on satin or bolting cloth, which is a thin, pure silk.

In the early 1800s, as interest in embroidery went into a decline, it was replaced by the painted picture. Ladies were no longer willing to spend so much time on intricate needlework. Drawing and painting were now considered essential accomplishments for genteel young ladies and were added to the subjects offered at the girls' schools.

Velvet painting came into fashion during the period between 1810 and 1840. The fashion most likely came here from England, as it was taught there as early as 1800. Soon velvet painting was added to the curricula of American girls' schools, such as Mrs. Byron's Boarding School for Young Ladies of Greenwich, Connecticut, in 1812. A year later Mrs. Rowson's Academy in Boston was teaching "drawing and painting on wood and velvet" (*Boston Daily Advertiser*, March 20, 1813).

New, and sometimes short-lived, schools were opened up to teach painting on velvet and other arts. The following notice appeared in the *Carolina Sentinel* (New Bern, North Carolina), May 31, 1823:

> Painting School, &c. Mrs. Gerard has the honour to inform the Public in general, and the ladies of Newbern in particular that she will teach Painting on velvet, according to the new method, by which Scholars may obtain a perfect knowledge of the art in twenty lessons. Specimens of her Drawing may be seen at any time at her house, near the Market; which she hopes (when examined) will procure her the support and patronage of a liberal community.

People were very eager to add culture to their lives, and many became amateur artists. Painting was not confined just to schoolgirls. America was growing and prospering at an astounding pace. Idealism and optimism abounded. Americans personified the ideals found in the Declaration of Independence, confident that they could do anything and everything themselves, including producing their own art.

The first known book about velvet painting was an addition to a book about landscape painting published in 1804 in London by J.W. Alston. The 1805 edition was titled *Hints to Young Practitioners in the Study of Landscape Painting to Which are Added Instructions in the Art of Painting on Velvet*. This early book gives detailed instructions on how to make and mix the paints to be used, but it does not mention the use of stencils in the painting process.

Dozens of other popular art books, with equally long titles, became available. One worth noting is Rufus Porter's *A Select Collection of Approved Genuine, Secret, & Modern Receipts, Valuable and Curious Arts, as Practiced by the Best Artists of the Present Age* (Concord, Massachusetts, 1810). As Porter's title indicates, this book revealed the unknown "secrets of the artists" to the general public, including the use of the stencil. The art manuals were passed around the countryside and helped transform farmers and housewives as well as schoolgirls into "artists."

Itinerant art teachers traveled from town to town offering short courses of instruction. The following handbill was from a "Mr. Middleton," who taught "Poonah, Indian or Persian Painting on Satin, Velvet, Cotton, Wood, Glass, &c. by means of Indian Poonah's or Persian Theorems, which they are taught to make for themselves." He also sold colors, satin, velvet and "every other article connected with the art." There is a footnote at the bottom of the handbill: "Rooms at 74 Hamilton Street first door east of Mason's lodge, June 30, 1817."

The art-instruction books, itinerant artists, and girls'-academy teachers all approached painting primarily as a craft, not at all as an academic painter would. Copying was considered an acceptable art form, for realism was the goal. Students were encouraged to copy the lithographs, engravings, or painted models provided by the teacher. Stencils and the use of mechanical aids were also endorsed. Materials, and the methods of using them, were stressed. The whole painting process was thought of in terms of separate parts put together, step by step, much as a house would be constructed. This is what gives the theorems on velvet their stylized and somewhat stilted look.

The title of Matthew D. Finn's book, which was published in New York in 1830, illustrates this "craft approach" to painting: *Theoremetical System of Painting, or Modern Plan, Fully Explained in Six Lessons and Illustrated with Eight Engravings by which a Child of Tender Years Can Be Taught This Sublime Art in One Week*.

Mr. Finn's book appears to be the first art-instruction manual to use the word "theorem" in reference to stencils. "Theorem painting" referred to a mechanical method of

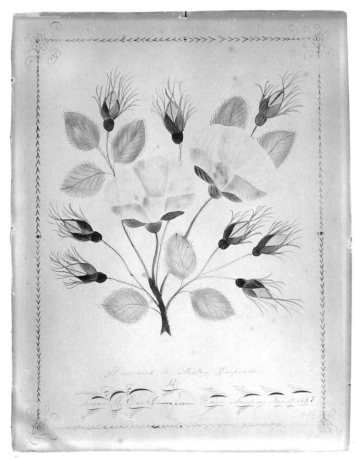

5. On May 2, 1833, Miss Melvine Palmer received a "Reward of Merit" for her attention to studies and good behavior from her teacher Leo J. Bennet in Upper Freehold, New Jersey. This certificate is part of a portfolio of schoolgirl watercolors. (Collection of The Historical Society of Early American Decoration—H.S.E.A.D.)

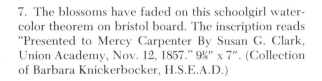

6. Painting, listed before embroidery in this advertisement, was among the subjects taught at the Berlin Academy, Berlin, Connecticut. This notice appeared in the *Hartford Courant* on May 18, 1813.

7. The blossoms have faded on this schoolgirl watercolor theorem on bristol board. The inscription reads "Presented to Mercy Carpenter By Susan G. Clark, Union Academy, Nov. 12, 1857." 9⅛" x 7". (Collection of Barbara Knickerbocker, H.S.E.A.D.)

8. This handbill of a Mr. Middleton lists the honors that he was accorded by the ladies of Edinburgh and Glasgow. Many itinerant artists and teachers came from or were educated abroad. They brought with them the latest techniques and art forms to an eager American public. (Reproduced from page 42 of *Pioneer Arts in America* by Carl W. Dreppard)

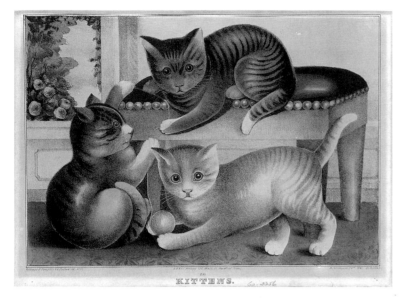

9. A charming colored lithograph titled *Kittens*, 1846. 9¼″ x 13″. (National Museum of American History; Harry T. Peters, "America in Stone" Lithography Collection; The Smithsonian Institution, Washington, D.C.)

10. *Three Kittens and a Ball of Yarn*, theorem watercolor on paper. 10¼″ x 14¼″. This theorem was either based on the *Kittens* lithograph illustrated in figure 9, or both derive from a common source. (Collection of Landmark Society of Western New York, Rochester, New York)

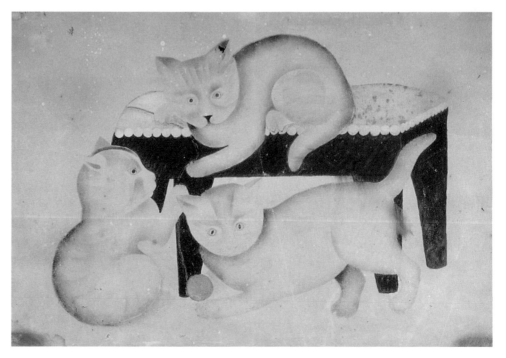

painting a picture by applying paint through a series of stencils or "theorems." The word "theorem" refers to the stencils used, not to the painting itself. Velvet painting was an early name given to this technique and has been used interchangeably with theorem painting on velvet. However, some velvet paintings were done without the use of stencils, so technically they are not theorem paintings.

The theorem technique of painting was applied to other backgrounds besides velvet. Paper, silk, bristol board, linen, white cotton, and light-colored wood were all used.

Theorem painting on velvet was also known by various other names, some of which were actually slightly different techniques; India tint-work, formula painting, Chinese painting, and Oriental tinting (stenciling on paper with watercolors).

Poonah work, which is the same as Oriental tinting, done only on silk, was another name that was used. This may have come from Poona, India, where early examples of this technique come from, or from the "poonah" brush that was used to apply the paint through the stencils.

Mezzotinting was another name and similar technique. Ground-up lead, called lead saucer or crayon, was carefully applied through a stencil and shaded with a brush. The picture was stenciled onto prepared paper or board and then "fixed" with mastic varnish. Sometimes colors were used. The term *mezzotinting* is derived from the mezzotint-engraving method, which produces a soft, velvety look in printing, but the techniques are unrelated.

The meanings of the various names given to stenciling on velvet changed over time as well. "Painting on Velvet" in the early 1800s usually referred to freehand painting, not stenciling. In 1831, *The Lady's Book* (later to become *Godey's Lady's Book*) included an article titled "Painting on Velvet" that described the freehand method. That same year there was another instructional article on "Oriental Tinting, or Poonah Work." It describes how to trace and cut a "formule" and how to stencil with the "common style of watercolours" on drawing board. *Godey's* again included instructions for "Painting on Velvet" in 1854, after "numerous inquiries have been addressed to us." This time, the instructions are for stenciling on velvet, "done with formulas, somewhat in the manner of the old Poonah paintings, except in this case the colors are moist."

When and where the first stencils were used to create a painted effect is not known. The Chinese and the Japanese were stenciling temple walls and textiles as early as the eighth century.

In the 1700s, the Western world imported from China many decorative items including lacquer work, porcelain, and albums of pictures painted by the Chinese on what they called "rice" paper. It is not really paper but a material called "pith," which is taken from a tree in China that looks like a sycamore. The white pith, which is found beneath the bark of the tree, is pounded paper thin, giving it a soft, velvety appearance.

Europeans quickly developed methods to imitate the Chinese decorated imports. Factories were started in England, France, and Holland to make their own china. A varnish was developed that had the appearance of Chinese lacquer. Pith was not available to paint on so velvet was substituted because of its similar texture and appearance.

Painting on velvet was being done in Europe well before 1800. However, the earliest-known date on a velvet is 1808. These fine early examples done with a stencil attempted to create realistic fruit and flowers primarily on hand-screens and firescreens. The early velvet was of a much finer weave and tighter pile than what is now produced. None of these early works were crude or primitive in execution, like many of the American examples are that survive today. The units of the stencils have been cleanly painted and joined, the shading is well done, and there is no overpainting other than fine, freehand painting to add veins, stamens, and tendrils. Overpainting is the technique of touching up the painting to hide mistakes or imperfections like poorly joined or cut stencils.

It was an era of fine craftmanship, and the technique was known by only a few people at the time. The popularity of the imported Oriental pith paintings and their fine European copies is the reason that velvet painting came to be added to the curricula of female seminaries in the early 1800s.

Although theorem painting on velvet was supposed to be an art that "even a child of tender years" could master, it could become a lengthy, complicated undertaking if the painter had to prepare all the colors and other materials herself. The art-instruction books include directions for making colors, and they are similar to preparing recipes from a cookbook.

In *The Art of Drawing and Colouring from Nature, Flowers, Fruits, and Shells. Correct Directions for Preparing Most Brilliant Colours for Painting on Velvet with the Mode of Using Them*, by Nathaniel Whittock, Esq., London, 1829, "The colours required for painting on velvet are carmine, hair saffron, blue, brown, orange, purple, green and verdigris."

The color yellow is made by taking "four ounces of French berries, pounded very fine, a pint of spring water, and one ounce of alum, with a piece of gum dragon, half the size of a nutmeg; boil the whole in an earthen popkin till the liquid is reduced to half the quantity, strain it through cambric for use." Purple is made by taking "six ounces of logwood chips, the best that can be procured, a small piece of gum dragon, an ounce of alum, and a pint of spring water; boil the whole together till the liquid is reduced to half the quantity, and it will be fit for use."

Whittock also says that "These colours are sold, ready

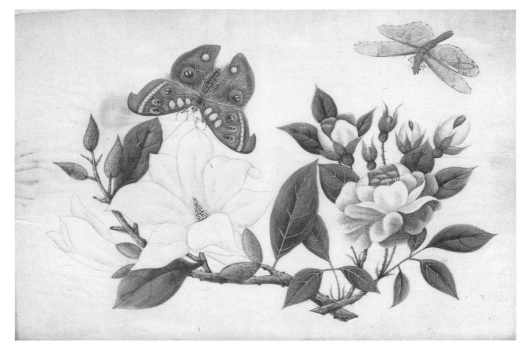

11. The colors in this Oriental painting on pith, c. 1840, have remained beautifully vibrant through the years. 8″ x 10″. (Collection of Helene Britt, H.S.E.A.D.)

12. The castle in this theorem landscape suggests that a European engraving was the design source. 19½″ x 23½″. (Collection of Sally Lovely, H.S.E.A.D.)

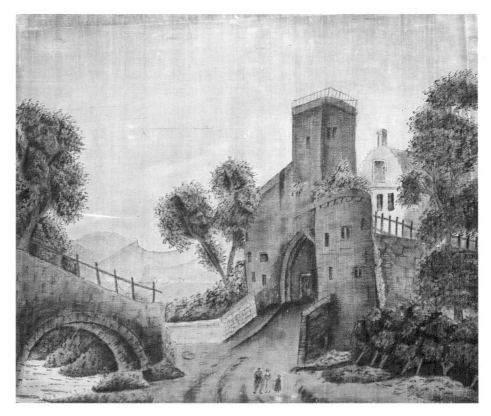

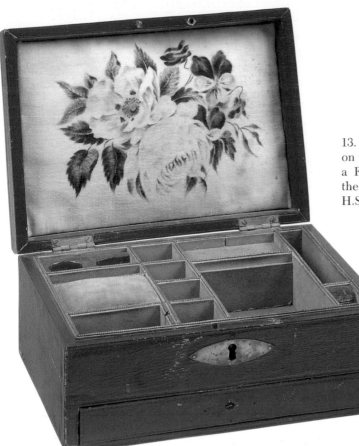

13. This wooden box with a velvet theorem painting on the inside of the lid is trimmed with *passepartout*, a French gold foil that was popular for trimming the edges of boxes and pictures. (Collection of H.S.E.A.D.)

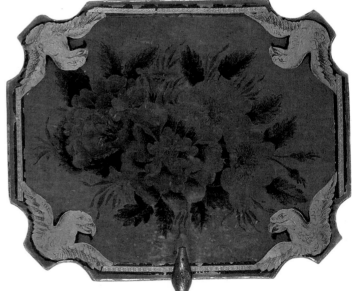

14. The eagles and border trim on this hand-screen are made with *passepartout*. (Collection of H.S.E.A.D.)

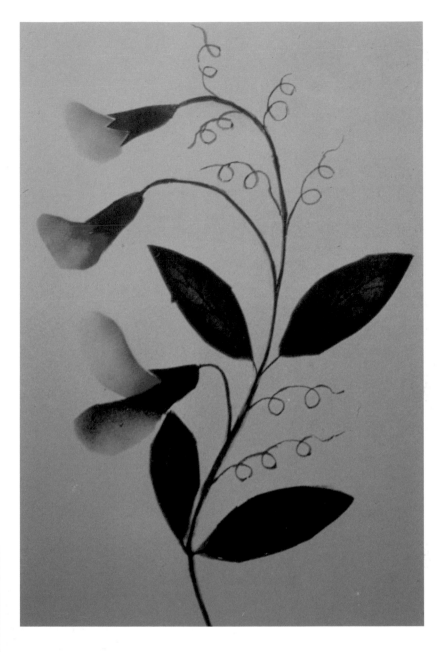

15. Watercolor theorem on paper of a peaflower, together with a peaflower stencil. (Collection of H.S.E.A.D.)

16a. This paper stencil was used to make the Family Record theorem illustrated in figure 16b. Photograph courtesy H.S.E.A.D.

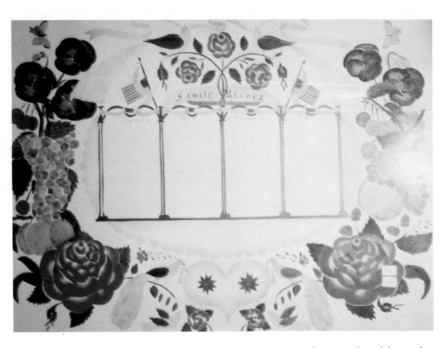

16b. This Family Record theorem on paper is a good example of how the theorem method of painting was used to decorate important family documents. Photograph courtesy H.S.E.A.D.

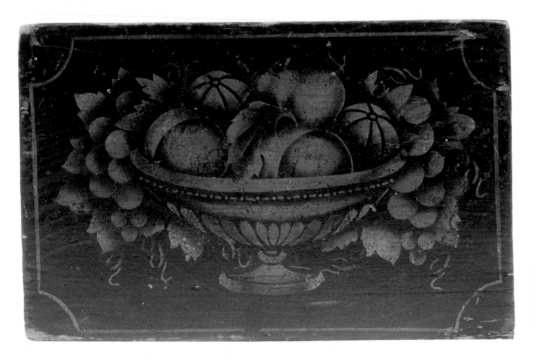

17. Stenciled with bronze powders, this top of a grain-painted box features a bowl of fruit that is very similar to those found in theorem paintings. Photograph courtesy H.S.E.A.D.

prepared, at most of the fancy colour shops, at about two shillings per bottle." Obviously, buying the colors was a much easier process unless great quantities were needed.

In general, the paints used were powdered colors mixed with gum tragacanth (or dragon) and water until they had the consistency of cream or starch. The gum tragacanth acted as a binder to keep the colors from running under the stencils. The teacher usually provided the colors for the students in the girls' academies, either by making her own or purchasing the colors or "saucers" as they were called.

The painter must also have velvet to paint on. A notice appeared in the *New York Evening Post* on October 6, 1818: "A few pieces of White Velvets for painting on for sale at 150 Broadway by Philbrook & Peters." In Whittock's book he says, "The velvet must be of fine white cotton, free from knots; it will be necessary to strain it on a board, nailing it round the edges and on the back."

Brushes were needed for applying paint to the velvet. According to Whittock, "The brushes made for this purpose are small hog's-hair tools, cut nearly down to the handle…They must be procured of different sizes, and every colour must have a separate brush." These brushes were small and stiff, sometimes called "scrubs." A soft brush called a camel's-hair "pencil" was used to add fine line details freehand after the stenciling was completed.

All of the necessary supplies, including patterns, were available commercially at an early date. The following advertisement appeared in the *Boston Daily Advertiser* on January 1, 1816:

Painting on Velvet etc. Just opened at the Music Salon and Variety Store over Messers. Callenders, No. 40 Marboro St. Complete Boxes of colors for painting on velvet—also a variety of elegant velvet patterns etc…. Sable, Camel's Hair brushes and Lead Pencils, Bristol boards…together with an assortment of high finished Drawings (most excellent studies) consisting of groups of Flowers, Single Flowers, Landscapes & Fancy Pieces.

The subject of the painting must be chosen, and according to Whittock, "It is usual to take the subject for the velvet paintings from drawing or prints previously executed." Still-life compositions of fruits and flowers were the most common subjects. They might be arranged in a basket or bowl with lots of leaves, tendrils and vines, with an occasional bird or butterfly.

Whole pictures may have been copied, or a simplified version that left out the parts too hard to copy. Others might have just a single flower or fruit taken from a picture. Another possibility would be an arrangement of elements from several pictures or models, such as fruit from one picture and a bird from another.

Landscapes and biblical scenes were a more ambitious undertaking, combining stenciling with a lot of freehand painting, and they are not commonly found today. Sometimes the landscapes have castles or other elements that give them a "European look." Most likely the artist used an imported engraving as the model.

Mourning pictures, painted in memory of deceased family members or friends, were similar in composition and painting technique to landscapes and biblical scenes. They were popular from the early nineteenth century through the Victorian era.

Theorem painting on velvet was a versatile craft; many other lovely items could be made in addition to pictures to hang on the parlor wall. Stenciled velvet made beautiful bell pulls, ball gowns, ribbons and belts, handscreens and firescreens, purses and bags, sewing cases and garters, to name only a few. In Mr. Middleton's handbill of 1817 he lists a variety of items appropriate for theorem decoration. Charming, handmade valentines were also painted using the theorem method on paper. Two examples are given in the pattern section of this book.

Different methods were used to paint on velvet, and sometimes more than one method was employed in the same painting. The freehand method is probably the oldest. The velvet was pinned over the chosen design, held up to a well-lighted window, and the pattern was then carefully traced on the velvet with a pencil. An error in tracing on the velvet could not be erased, as it could on paper.

An alternative method of transferring the pattern to the velvet was recommended by *The Lady's Book* ("Painting on Velvet," 1831).

It is a safer method, however, to make the sketch on drawing-paper, and to prick the outline very closely with a fine needle; then, the velvet being previously nailed on a flat piece of wood of a proper size, the pricked pattern may be laid over it, the roll of list [cloth] dipped in the black-lead powder, and rubbed regularly over the pattern from side to side, observing to touch every part, and on removing the pattern, a perfect outline in black dots will appear on the velvet.

After the design was on the velvet, the liquid colors were applied freehand with brushes.

The theorem or stencil method involves the use of theorems made of "horn" paper. Sheets of drawing paper were coated on both sides with linseed oil to make them transparent, and they were then dried thoroughly. Next, both sides of the paper were coated again with a varnish made from balsam of fir and spirits of turpentine and allowed to dry again for a period of several days to a week. Sometimes the paper was varnished a second time. The varnish stiffened and sealed the paper and kept the paint from bleeding through the stencil.

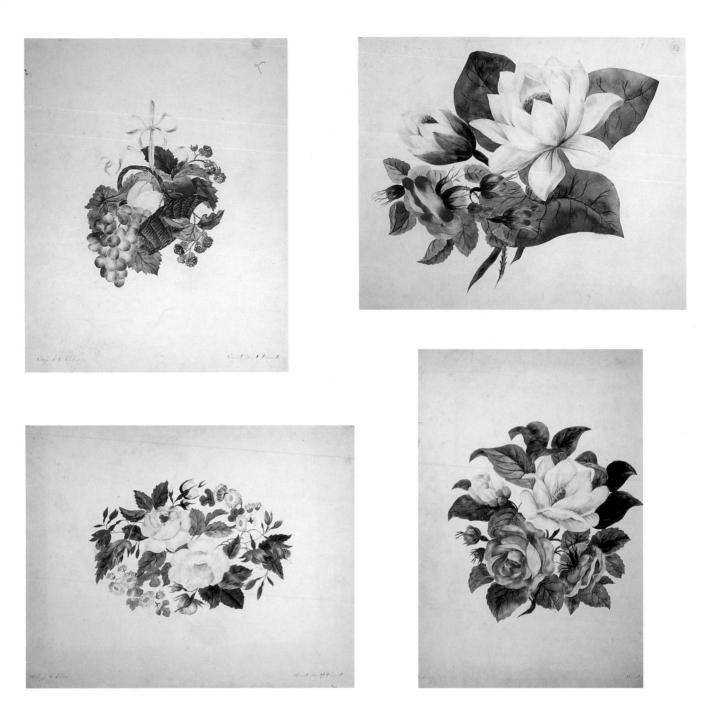

18a–18d. These four theorems were executed on bristol board and signed by J. C. Ehler, Mount St. Vincent's Seminary. (Photographs courtesy S. Dotter)

FALLAWATER OR TULPEHOCKEN.

D. M. DEWEY'S SERIES
COLORED FROM NATURE

AMERICAN
FRUITS AND FLOWERS

STUMP THE WORLD.

D. M. DEWEY'S SERIES
COLORED FROM NATURE

AMERICAN
FRUITS AND FLOWERS

19. Two colorful examples of Dewey prints. (Collection of Linda Carter Lefko, H.S.E.A.D.)

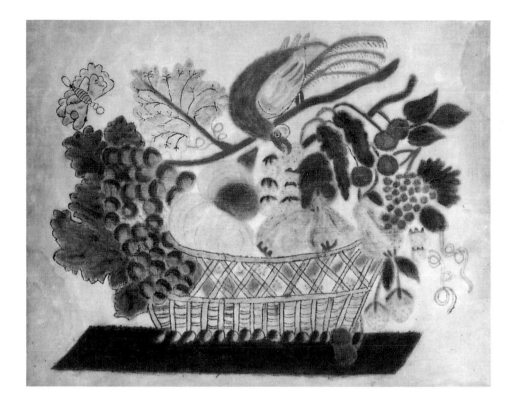

20. This is a lively and lovely rendition of the popular design of a bird on a basket of fruit. 14″ x 17″. (Collection of Ruth Flowers, H.S.E.A.D.)

21. *Still Life with Bowl of Fruit, Bowl of Strawberries, and Peach Half* is a handsome example of Emma Jane Cady's style of theorem painting on paper highlighted with mica chips. 14″ x 10″. (Private collection)

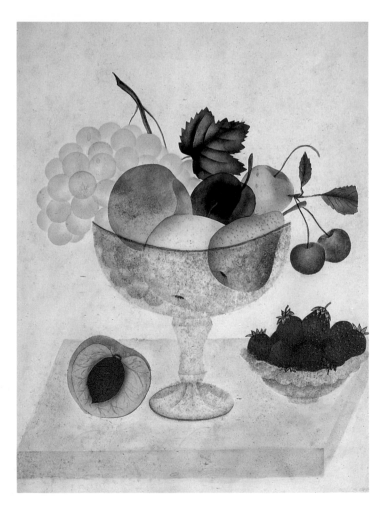

22. This brightly colored and well-proportioned composition shows the crisp edges of theorem painting on velvet. The lack of detail in the basket suggests that the painting was not completed. 15″ x 18″. Photograph courtesy Helen Spear, H.S.E.A.D. (Private collection)

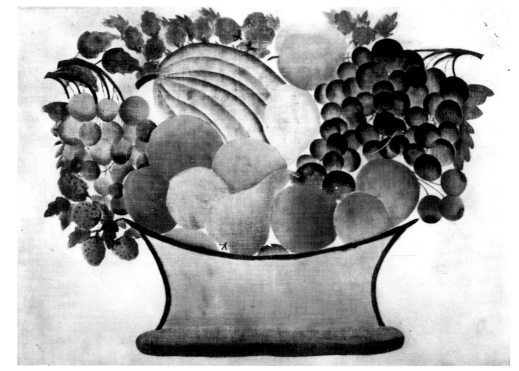

23. This loosely arranged compote painted on velvet is a typical example of an informal theorem. 17″ x 20″. Photograph courtesy America Hurrah Antiques, N.Y.C. (Private collection)

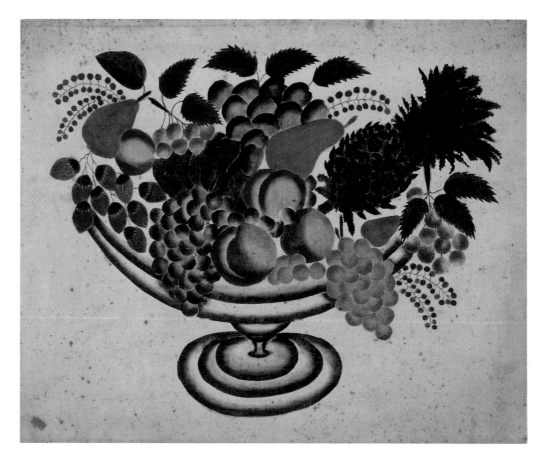

The next step, according to the book *Art Recreations* (J. E. Tilton & Co., 1860), was to "Trace the picture you intend to copy on white paper, with a soft lead pencil, then mark those parts which do not touch each other with a figure 1." Trace the next set of areas that are non-connecting and mark them with a number 2, and so on until the whole design has been included.

Art Recreations continues, "Lay the horn paper over the sketch, and trace with a sharp pointed pen knife or large pin, all the objects marked '1'; Mark another piece of horn paper for theorem '2,' and cut again, thus continue till you have enough theorems cut for your whole picture."

In this "fixed-stencil" method, all the stencil shapes were cut exactly as they appeared in the model being copied. If only part of the pear showed in the picture, that is all that was cut.

Another way of stenciling involves assembling individual theorem units of fruit, for example, to make a picture. Stencils were moved around, and one might be used repeatedly, such as an individual grape or leaf. This method allowed the artist to change or create a new design easily by rearranging the units.

To begin painting, the first stencil was placed on the velvet and held in place with weights or tacks. The openings in the stencil were carefully filled in. The brush was filled with paint while trying to keep it as dry as possible. With the brush held upright, the color was applied gently in a circular motion until the proper depth of color was achieved. Additional shading could be blended in over the base color. Each succeeding theorem had to be carefully placed on the velvet so it would match up with the areas already painted. When all the theorems were completed, the fine-line details were painted in freehand.

Few original early stencils have been found. This fact suggests that many velvet painters rented or used the stencils provided by their teachers, thus avoiding the task of making the stencils and cutting them, or that the stencils were simply discarded after use. Professionally cut stencils were on the market by 1835. Stencils were made for theorem painters and also glass and clock decorators, lampshade makers, and furniture decorators.

Detailed descriptions of exactly how to paint all kinds of flowers and fruit are found in the art-instruction manuals of the period, and many schoolgirls kept notebooks filled with detailed instructions. In the article "Old Theorems Come to Light" by Emilie Underhill (*The Decorator*, Spring 1959) the author discusses one of these notebooks that was found in an attic on Long Island, inscribed "Elizabeth A. Burling, Wesleyan Seminary, New York, October 30, 1826." Between the pages of notes and directions were several theorem paintings and some stencils. Elizabeth recorded the painting of a Damask rose in the following way.

It is painted with pink saucer, shaded darker with the same; the stalk is olive green briared with carmine; the leaves are first painted with a thin, soft chrome, shaded with blue saucer or mineral green, some of the leaves are tinged on the edges with carmine, and veined with the same; the calix on the buds of a light green, touched off with carmine.

Velvet painting was not just for the ladies. An unnamed gentleman made an entry in his diary on April 22, 1832, in Georgetown, D.C.: "...I went down to Alexandria to take a lesson on painting on velvet and finished two pieces and it was said to be the handsomest in Georgetown."

Some women continued to paint beyond their days at seminary school, either for pleasure or as a means of employment. During the period that theorem painting was popular and beyond, furniture and tinware were produced and decorated with bronze-powder stenciling and freehand painting.

Theorem painting found a commercial outlet as one method used to produce colored plates of fruit, trees, shrubs, and flowers that were created for the nursery business. These plates were bound into books carried around by nursery salesmen to help sell plants to farmers and townspeople. The concept for the "fruit plates" was originated and developed by Dellon Marcus Dewey in Rochester, New York, in 1858. Other companies soon followed, and many women were employed to paint the plates.

These plates were a great success with the American public. The lush array of perfect-looking fruit and flowers in lovely shaded colors was hard to resist. Their appeal was enhanced because they were done in a simple, stylized art familiar to the average person.

The quality of theorem paintings deteriorated when the technique became part of the curricula of the female seminaries. Maria Turner, in her book *The Young Ladies Assistant in Drawing and Painting*, Cincinnati, Ohio, 1833, made this comment:

> ...every Miss, however deficient, imagined that she might become an artist, if she could pay the sum of three dollars to some teacher who pretended to teach velvet painting, for that price, in six lessons... Frightful specimens were daily multiplied, and the few who admired and had perfect knowledge of the art, soon were disgusted with it; and let it drop into oblivion; so that we now scarcely hear it mentioned, or see traces of it, except when we travel through the country where painting has not made great progress.

As in any creative enterprise, some theorem painters were better than others. It is obvious that J.C. Ehler's skill as a theorem painter improved during her studies at Mount St. Vincent's Seminary. From a poorly cut basket of flowers, she honed her skills and gradually improved to

24. A charming and well-executed wreath of flowers with additional corner motifs that was painted by Sarah Green, and her initials appear at the bottom of the piece. 15½″ x 15½″. (Collection of Landmark Society of Western New York, Rochester, New York)

25. This typical rendition of fruit in a basket was created by Amanda Green, sister of Sarah (see fig. 24) and daughter of Deacon Russell Green of Rochester, New York. (Collection of Landmark Society of Western New York, Rochester, New York)

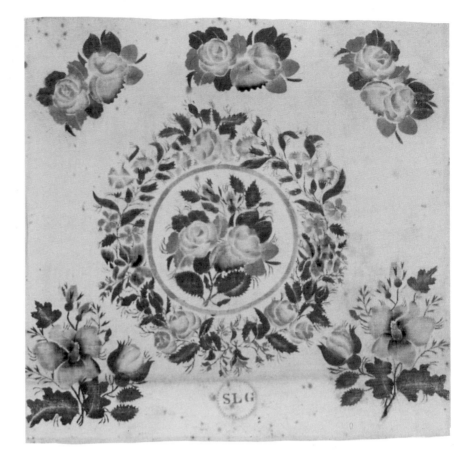

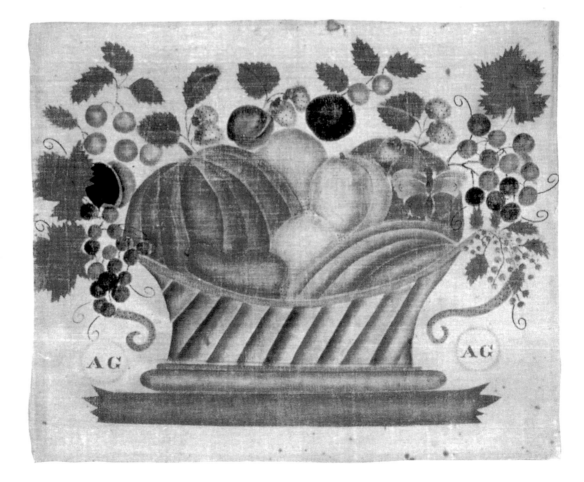

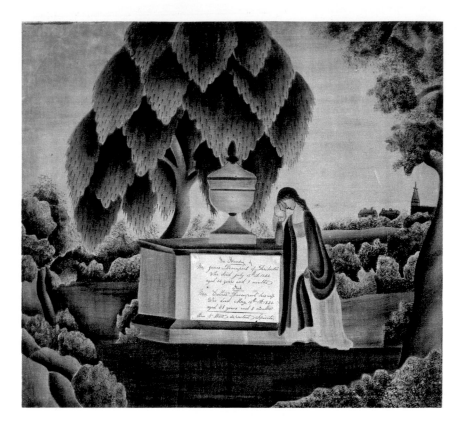

26. Davenport Family Memorial, artist unknown, 1834–1840, Dorchester, Massachusetts. Mourning pictures were painted as well as stitched. In this piece the bushes and foliage of the trees in the foreground are painted to resemble needlework stitches. The crisp edges throughout the memorial indicate the use of stencils. The inscription on the tomb was made in ink on applied paper. 14″ x 15⅝″. (Courtesy Abby Aldrich Rockefeller Folk Art Center, Williamsburg, Virginia)

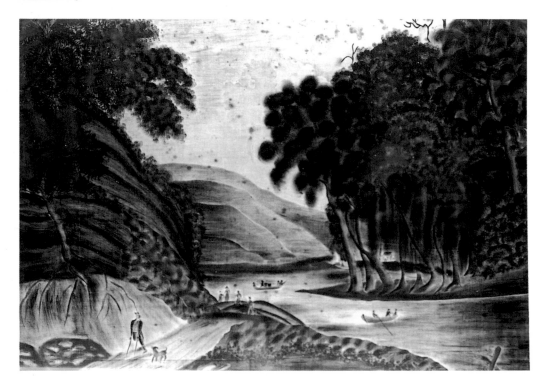

27. This rare theorem landscape was found unframed at an auction, where it was being used as a dustcloth by the auctioneer! It is a delightful pastoral scene. 18″ x 26″. (Collection of Helene Britt, H.S.E.A.D.)

28. It is unusual to find a formal stenciled border framing a theorem painting on velvet. This is certainly a handsome example. 12″ x 12″. (Collection of H.S.E.A.D.)

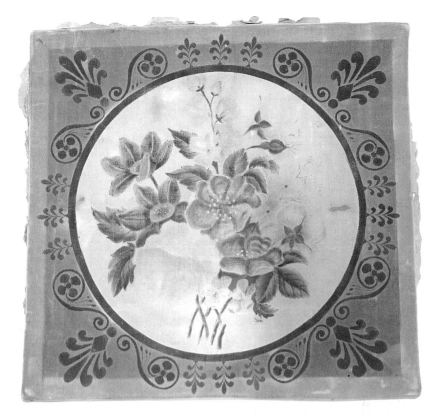

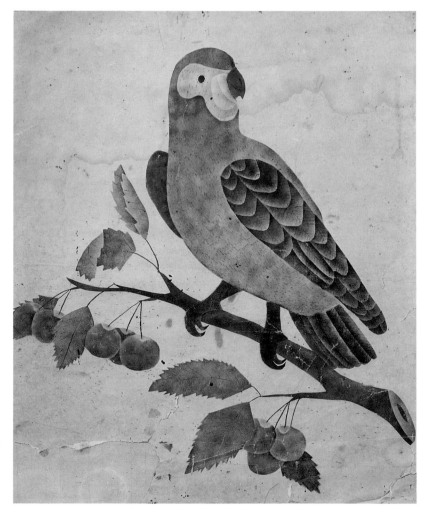

29. This striking parrot on a sprig of cherries is an unusual subject that has been expertly executed on paper. Photograph courtesy America Hurrah Antiques, N.Y.C. (Private collection)

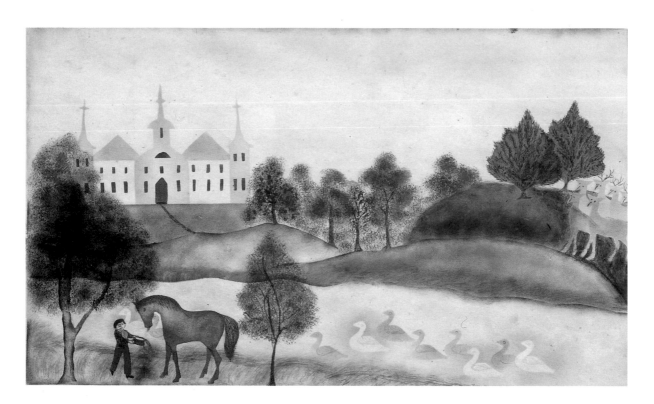

30. The positive and negative stenciling of the swans make this theorem on paper a wonderful find. Note also the deer surveying the scene. 6½″ x 10¾″. (Private collection)

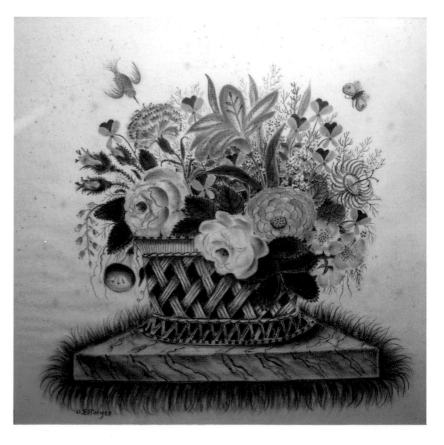

31. D. Y. Ellinger is a modern stenciler whose theorems are prized. This is a typical and attractive example of his style. 16½″ x 16½″. (Collection of Ruth Flowers, H.S.E.A.D.)

32. The extraordinary feature of this velvet piece is the border, where the repetition of a leaf stencil creates an intricate frame for the central subject. 27″ x 26″. Photograph courtesy America Hurrah Antiques, N.Y.C. (Private collection)

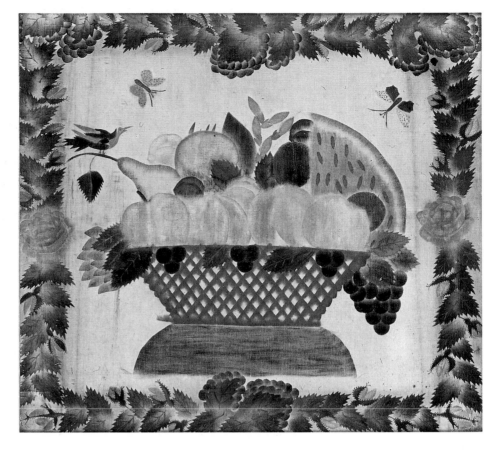

33. The special interest of this fascinating theorem on paper is the dominant use of blue throughout. 17½″ x 21½″. Photograph courtesy Michael Haskins Antiques, Palmyra, New York. (Private collection)

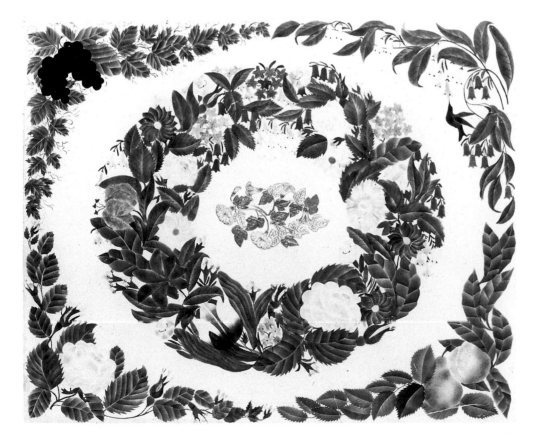

34. This Daniel Stevens–Sarah Pratt marriage certificate and family register on paper is a fine example of the effective combination of architectural and floral motifs. The flowers and trees are reminiscent of Shaker spirit drawings. 14½″ x 19½″. Photograph courtesy America Hurrah Antiques, N.Y.C. (Private collection)

35. This bowl of fruit with a border that is also stenciled is similar in pattern to some stenciled bed covers. The boldness of color and looseness of design lends an almost whimsical quality to the velvet painting. 15½″ x 22″. Photograph courtesy America Hurrah Antiques, N.Y.C. (Collection of Mr. and Mrs. Edwin C. Braman)

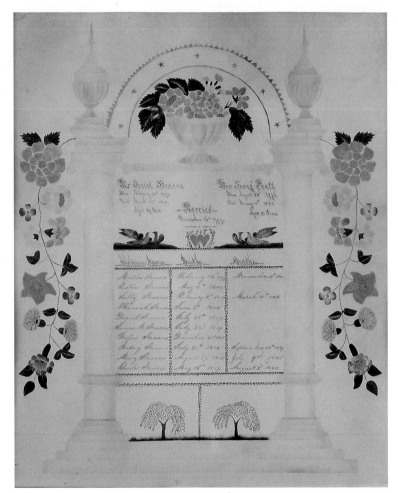

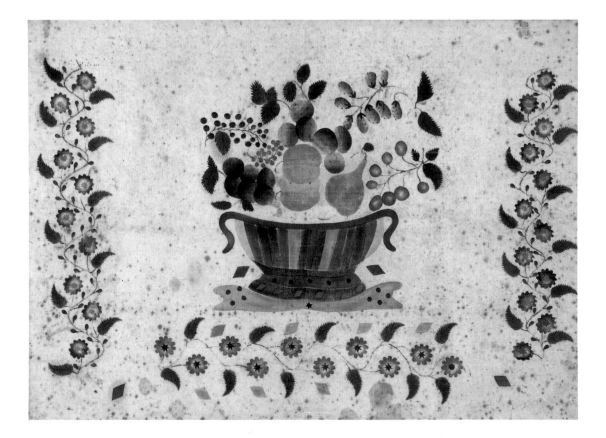

produce the elaborate floral theorems pictured in figure 18. These theorems on bristol board show how the intensity of color is preserved when a theorem is executed on paper. Among the fair number of theorem paintings on velvet that have survived today, the same patterns with slight variations appear over and over, differing mostly in color and quality of execution.

The painter's goal was to try to make the picture look as much like the model as possible, so there is little spontaneous expression. Charles Messer Stow, in his article "Primitive Art in America" (*The Antiquarian*, May 1927), says of the early artist, "He did not stifle his originality; he was not aware that he had any originality to express..."

With a few exceptions, very little is known about the individuals who practiced the art of theorem painting. Not many of the surviving examples are signed and most of those artists remain unknown. The signatures are probably not significant, since every student who attended a female seminary that taught theorem painting was likely to have made one.

One notable exception is Emma J. Cady. Her painting *Still Life with Bowl of Fruit, Bowl of Strawberries, and Peach Half* is an innovative example of the use of the theorem technique in painting on paper. It varies from what is considered a typical theorem in several respects. First of all, it is done on paper and the paper receives the pigment quite differently than the velvet does. Secondly, tiny flakes of mica were glued to the compote, giving it a shimmering, glassy quality. It was a technique that was rarely, if ever, used in theorem painting on velvet.

Emma J. Cady was born in East Chatham, New York, in 1854 and died in 1933. Active in the 1890s, she painted her theorems long after the technique had gone out of vogue. Most of Cady's known works were done on paper, using a combination of transparent and opaque or gouache watercolors. Her skillful execution, use of color, and arrangement of composition show her mastery of the still-life art form, considered by many to be the most difficult to achieve successfully.

The work of David Ellinger of Trapp, Pennsylvania, has become collectible, for he is a modern theorem painter. During an interview at age seventy-six, he enthusiastically recalled the 1930s when he was working on drawings for the Index of American Design, a pictorial survey of popular folk art commissioned by the government as a W.P.A. project. Mr. Ellinger was responsible for the Fraktur and pottery drawings in the Index, and he felt that this experience inspired his theorem painting. He works with oils on velvet and composes his own pictures, many of which are done in the intense colors of Pennsylvania German Frakturs. His theorems were always signed D.Y.E. or D. Ellinger—never David—and they are never dated. Hearts, compotes, baskets, and birds are some of the motifs often used by Ellinger over the past forty-five years. His work sometimes commands high prices at auctions, bridging a gap between the antique and the new, and the popularity of Ellinger's theorems has helped spark a revival of interest in the art form.

Theorem painting is enjoying a resurgence in popularity today for many of the same reasons that it was popular in the 1800s. People still enjoy making decorative items for their homes, and theorem paintings go very well with antiques and the ever-popular "country look" in home decorating. Original theorems are somewhat scarce and expensive to buy, so why not make your own? Even a child of "tender years" can do it, once the technique is learned!

As has been noted in the first section of this book, the term *theorem painting* refers to the mechanical method of creating a picture by applying paint through a series of stencils or "theorems." Thus, the word *theorem* refers only to the stencils used, not to the painting itself. The subject matter of theorem paintings was typically fruit and/or flowers in baskets, bowls, or compotes, or artistically arranged florals in round or oval shape.

It should be noted, however, that today, when a typical subject such as a basket of fruit is found, it is often called a theorem, referring to its typical design. When theorem painting was first established as a recognized art form in the early 1800s, it meant only the painting technique. Numerous objects to be found in antiques shops and illustrated in publications are erroneously called theorems. Primitive painted boards, country-painted tiger-maple boxes, embroidered silk pictures, and lovely watercolors are all referred to as theorem when the subject matter was like that of theorems, but there were no stencils involved in the execution.

The subject matter of a theorem can affect its desirability to collectors and, therefore, its price. Some patterns were readily available either from teachers or in publications of the period, and for this reason one is apt to see quite a few versions of the same basic design. We have seen seven interpretations of an upside-down-bird theorem, each having been executed by a different hand and having slight differences in technique. Desirability is completely subjective as far as subject matter is concerned. Some people prefer the klunky look of a primitive basket or bowl filled with blotchy fruit. Others prefer a lovely transparent compote overflowing with a gracious arrangement of fruit and flowers. Scenic and allegorical theorems, along with mourning pictures executed with stencils, are very rare indeed. When such theorems are found, they usually combine stencils with freehand painting. Units that usually were stenciled were tree trunks, houses, and land formations, and these were incorporated with areas of freehand painting around them, such as grass and foliage.

Theorems were executed on velvet, linen, cambric, and many different kinds of paper. Every still life painting on velvet or paper isn't necessarily a theorem. Many watercolors are mislabeled as theorems. As was mentioned earlier in this book, watercolor paints were mixed with a variety of different gums, each serving a different purpose. Gum arabic was used as a binder and an adhesive with watercolor. An excess of gum arabic causes a hard or glittery surface that can often be seen on paper theorems and watercolors and occasionally on velvets. It has been noted that where the pigment is most intense, mold will often develop between the velvet and the glass. This is probably due to the fact that dampness has combined with the starch in the gums and thus formed a suitable growing medium for mold. Moisture causes the decomposition of the gums that were mixed with the pigment and seems to occur where the application of gum and pigment is heaviest. References to gum tragacanth, a binder or thickener for pigments, and oxgall, a wetting agent that increases the flow of paint on a surface, have also been found in theorem research. Gum tragacanth was probably used much the same as gum arabic, and oxgall was probably used as a medium with the watercolor to put in detail work.

On old or antique velvets the color is often what is termed *fugitive* or changed from the original color. A variety of atmospheric conditions—light, moisture, and air pollutants—combined with framing methods reacting with the paints and gums cause this color deterioration. It is difficult, at best a guess, to determine what the original colors were at the time of painting. It is generally known that reds tend to turn brown, blues and greens mixed with blue darken on velvets. On paper theorems the color is much less fugitive. It has been said that the color seen today on antique velvets is probably much more pleasing than it was when they were painted, for colors were quite bright in that period. Exquisite shading of two or three different colors on one unit would indicate that the painter was experienced and highly skilled at the craft. The colors used can obviously affect the desirability of a theorem, but as always, it is a matter of personal choice.

When one studies old theorems, one often notes that the units don't fit together perfectly, leaving an area where the background shows through. The quality of execution is something to consider when you are thinking of purchasing an original theorem: do the units fit together perfectly, thus showing the artist's skill in cutting the stencils? Do the fineline details that were brushed on add to the overall design of the painting, or are they overworked in an effort to cover up poor cutting? Generally speaking, paper theorems have more fineline details than velvets. Velvet theorems tend to have more depth and shading than paper theorems and might be a good choice for a first purchase.

The fragile nature of textiles and paper and a lack of concern for the materials at the time of mounting and framing the paintings have caused many theorems to deteriorate in their original frames. The nap of the velvet will often stick to the glass when a theorem is removed, and the velvet can thus be destroyed. Some velvet theorems were stretched over wooden mounts similar to

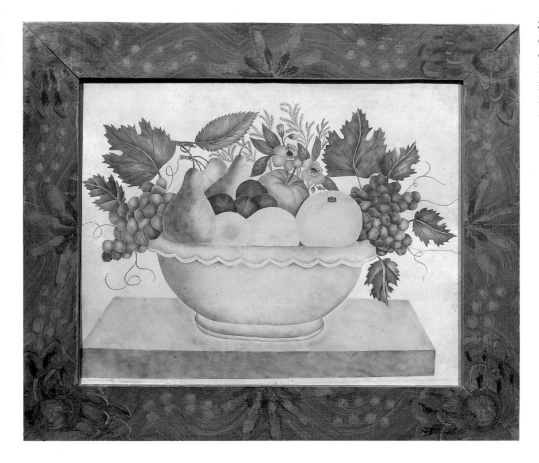

36. The soft palette gives special distinction to this beautifully executed theorem on paper, which is further enhanced by the unusual painted frame. 10¾″ x 13½″. Photograph courtesy America Hurrah Antiques, N.Y.C. (Private collection)

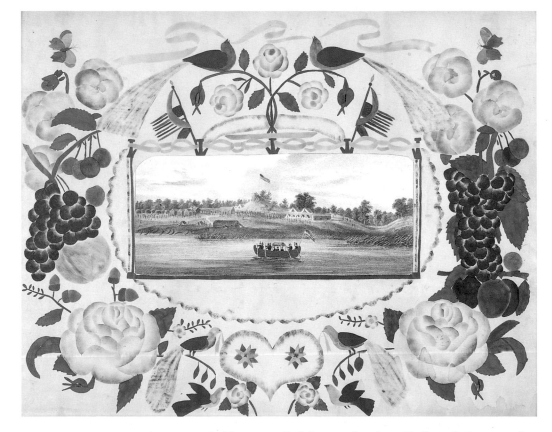

37. A patriotic watercolor is encircled by a stenciled theorem border with flags, fruit, peacocks, and flowers. The border is very similar to the one used on the Family Record in figure 16b. 22¼″ x 17¼″. Photograph courtesy America Hurrah Antiques, N.Y.C. (Private collection)

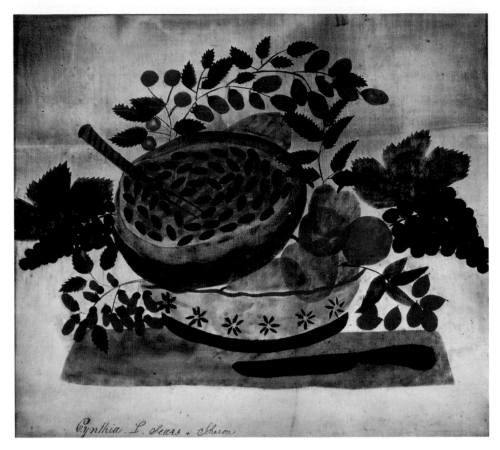

38. The naïve drawing of the over-sized watermelon and cherries in the small patterned bowl shows an unusual sense of design and disregard for tradition. The colossal seeds and stenciled fork and knife are wonderful additions to this theorem on velvet inscribed "Cynthia L. Sears & Sharon." 21″ x 23½″. Photograph courtesy America Hurrah Antiques, N.Y.C. (Private collection)

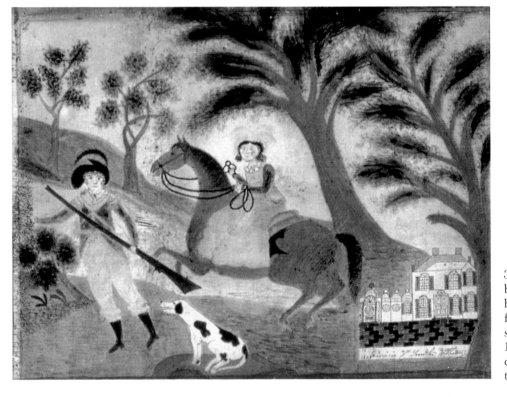

39. This wonderful lady on horseback, who is out with her man while he is hunting, is a combination of freehand and theorem painting. It is signed "Erminia W. Smith Williston, 1828." 25¾″ x 21″. (Landmark Society of Western New York, Rochester, New York)

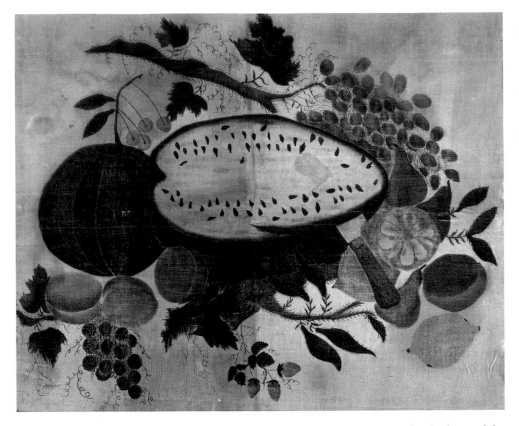

40. A huge watermelon in the process of being sliced is a unique focal point for this bountiful theorem of fruit painted on velvet. 15½″ x 19½″. (The Western Reserve Historical Society, Cleveland, Ohio.)

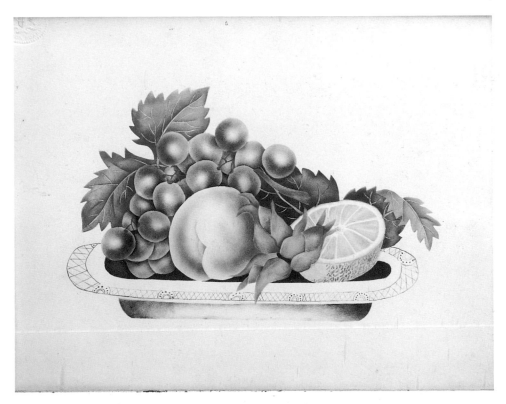

41. The sliced lemon adds a unique element to this softly colorful still-life theorem composition on paper. Photograph courtesy America Hurrah Antiques, N.Y.C. (Private collection)

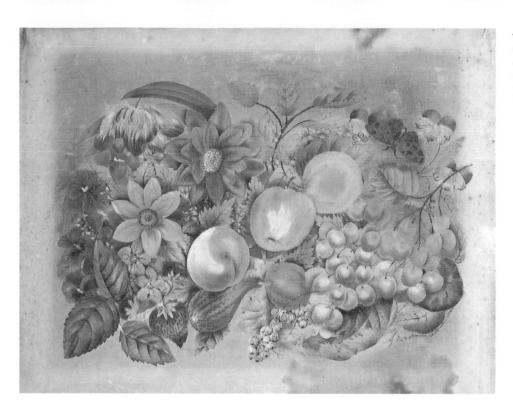

42. This free-flowing composition of flowers and fruit shows the discoloration of the velvet caused by the passage of time. (Collection of Ruth Flowers, H.S.E.A.D.)

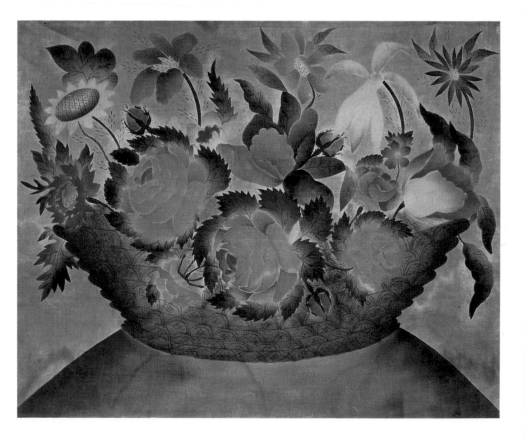

43. This bountiful basket of strikingly colored flowers is a brilliant essay in forms and colors. An almost identical example has been identified as having been executed at Mrs. Maul's School, Wilmington, Delaware, c. 1825. 18″ x 24″. Photograph courtesy America Hurrah Antiques, N.Y.C. (Private collection)

canvas stretchers and then put into frames. Where the wooden stretcher touches the velvet it causes discoloration by leaving a dark mark around the outside of the velvet that is the width of the stretcher. Both paper and velvet theorems were often backed with a thin wooden mount that, over time, discolors the painting and causes what is called "foxing," a spotting that will continue until conservation measures are taken to stabilize it. Recently, an antique theorem that was glued to a bristol-paper mount at the time of execution was successfully removed and conserved. The lines of discoloration in the velvet were actually the lines where the glue had been applied to the paper mount.

When you are thinking of purchasing an antique theorem consider the physical condition of the piece. Is there deterioration because of the way it was framed? Has it been damaged or torn? Often thin tears will appear where the paint has been heavily applied and the gums and pigments are deteriorating.

Is the theorem in its original frame? This is a very difficult question to answer, but it deserves consideration, for antique theorems are more valuable if they are found in their original frames. Generally, theorems were framed close to the painting so that the composition didn't appear to float. By inspecting the back of the painting it can usually be determined if the theorem was at some time removed from the frame and the original mounting material. As a general rule of thumb, square or rectangular framed theorems are earlier than those in oval or shield-shape frames. Many artists treat the framing as an integral part of their painting, and there is no indication that the theorem painters of the last century felt any differently. If a theorem in an original frame and mount is conserved, it is important to have documentation done as to its condition when the theorem was found and information on what sort of conservation was done, so that the theorem doesn't decrease in value.

When purchasing a theorem, all of the criteria, such as pleasing subject matter, quality of execution, color, and physical condition when found, are subjective. What appeals to one person will not be another's preference. Price is obviously an important point to be considered. The size of the theorem often affects the price, for small pieces are usually less expensive than large examples. Antique theorem prices have escalated along with everything else in the antiques market. Supply and demand, and the recent craze for an American country "folk" look in home decorating have affected theorem prices. Scarcity and the facts that they were not mass produced and historically were in vogue for a relatively short period, has made theorems even more collectible.

Paper theorems occasionally turn up in between the pages of family Bibles, often a repository for important sentimental items that have no real utilitarian value in everyday life. At a country auction a few years back, a wadded up velvet painting was being used to dust off merchandise before it was sold. Obviously, beauty is in the eyes of the beholder and there are still bargains to be had if one knows what to look for.

When considering the purchase of an antique theorem, it would be advisable to purchase the theorem from someone who will allow it to be authenticated before the sale is finalized. Because the art of theorem painting has been perpetuated, it is not difficult to produce theorems that closely resemble antique examples. Many new theorems are on the market today. Unless they are signed and dated it is difficult, at first glance, to tell if they are old. Studying theorems in the collections of museums such as the New York State Historical Society in Cooperstown, New York, the Abby Aldrich Rockefeller Collection in Williamsburg, Virginia, and the Maxim Karolik Collection at the Museum of Fine Arts in Boston, Massachusetts, will help the collector immeasurably. Museums are more than willing to share their collections when appointments are made in advance.

Materials Needed for Creating Theorem Paintings on Velvet

100% cotton velvet
.002 Mylar, matte finish on one side (polyester film)
Grifhold knife #24 with 7-B blades
1/2 yard contact paper
Stiff-bristle brushes, sizes 2, 4, and 6 (two each)
Liner brush, size 2
Tracing paper
Turpentine
Straight pins, thumb tacks
Sharp hard-lead pencil or fine-point technical pen
Homosote board that is larger than the theorem (or any flat surface into which a pin can be stuck)
Palette paper for oil paint and a palette knife
Ruler

Glass on which to cut the theorem
Masking tape
6-ply acid-free mat board on which to mount the finished velvet
Frame and glass
Muslin, needle, and rug thread
Master pattern of the theorem with units numbered
Tube oil paints: Alizarin crimson, cadmium red medium, Indian red, Venetian red, vermilion, Naples yellow, cadmium yellow medium, yellow ochre, raw sienna, burnt sienna, burnt umber, raw umber, Van Dyke brown, sap green, Alizarin green, Prussian blue, cerulean blue, Payne's gray, black, Permalba white.

Materials Needed for Creating Theorem Paintings on Paper

Strathmore 400 drawing paper
.002 Mylar, matte finish on one side (polyester film)
Grifhold knife #24 with 7-B blades
Several 3-inch squares of white cotton velvet
Liner brush, size 2
Tracing paper
Turpentine
Sharp hard-lead pencil or fine-point technical pen
Palette paper for oil paint and a palette knife

Ruler
Glass on which to cut the theorem
Masking tape
6-ply acid-free mount board—the size of the glass
Frame and glass
Master pattern of the theorem with units numbered
Tube oil paints: the same colors that are listed for velvet theorems

Supplies

Cotton velvet is available in a variety of colors (see illustration) from:

> Welch Haven Fabrics
> Route 4, Box 125
> Henderson, NC 27536

Mylar—.002 polyester drafting film, matte finish on one side, is available by the sheet from your local art-supply store or by the roll from:

> Bruning Division
> 1800 Bruning Drive West
> Itasca, IL 60143

Grifhold knife—Size #24 with 7-B blades is available from:

> Griffin Manufacturing Co.
> P.O. Box 308
> 1656 Ridge Road East
> Webster, NY 14580

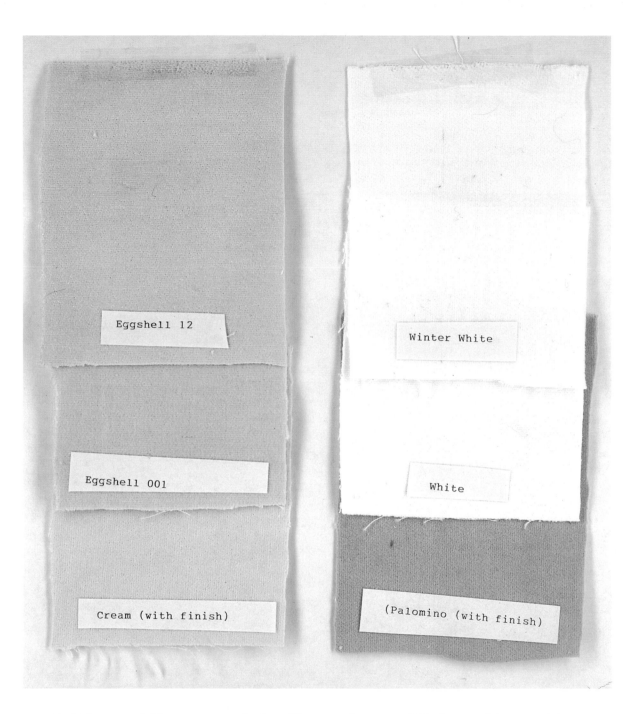

Eggshell 12

Winter White

Eggshell 001

White

Cream (with finish)

(Palomino (with finish)

44. Velvet is available in a variety of colors. These samples are available from Welch Haven Fabrics.

Preparation for Theorem Painting on Velvet

1. Place the master pattern in a fixed position on a flat surface.

2. Cut four pieces of Mylar all the same size, 2 inches larger than the outermost lines of the master pattern. This will give a 2-inch border around the pattern to protect the velvet during painting. There must be one sheet of Mylar for each group of numbered units (1, 2, 3, 4, etc.) indicated on the master pattern. Number each sheet of Mylar to correspond with the number of the units being cut on that sheet, #1, #2, #3, etc.

3. To create the stencils, center the sheet of Mylar that you have labeled #1 over the master pattern, checking to be sure there is a border of at least 2 inches surrounding the outermost lines of the master pattern. Tape the #1 Mylar sheet to the master pattern so that it doesn't shift during tracing.

4. With a hard-lead pencil or fine-point technical pen, trace all units labeled #1 on the matte side of the #1 sheet of Mylar. Be sure to trace a fine line exactly on top of the lines of the master pattern. The natural tendency is to trace to the inside of the master-pattern lines, and these underdrawn lines result in undercutting, which affects the final results.

5. On the sheet of Mylar labeled #2, trace all the #2 units. Using a dotted line, dot in two or three of the large units that are on the #1 stencil to serve as a key to help in correctly placing the succeeding stencils. Proceed, using the same method on each successive Mylar sheet—i.e. trace all #3 units to be cut, then dot in a few larger units from stencil #2, etc., until all units have been traced on the Mylar.

6. On top of a piece of glass, cut all the #1 units from the #1 stencil with the Grifhold knife. *Do not* tape the stencil to the glass, for curved units are cut more smoothly when the Mylar is turned on the glass as you cut.

Take care to cut on or outside of the traced line that you have drawn. Again, the natural tendency is to cut to the inside of the traced line, and this will affect the finished piece. *Do not* cut the dotted units on stencils #2, 3, and 4. Be sure to use a sharp blade. The blade can be resharpened on a sharpening stone, or use a new one. Keep turning the Mylar stencil while cutting, trying not to remove the blade from the cut. If an error is made and a repair is needed, apply clear scotch tape to both sides of the Mylar, and then recut.

7. The next step is to cut and mount the velvet for painting. If the frame size is not known, allow between 4 and 5 inches of extra velvet on all four sides, measuring out from the master pattern. If the velvet is wrinkled, smooth it by ironing with a steam iron on the wrong side. Cut a piece of contact paper the size of the Mylar stencil. After removing the backing from the contact paper, center it on the wrong side of the velvet (sticky side against the velvet). Press it on with your hand, making sure that the velvet is smooth and free of lint. This procedure will stiffen the velvet so that it doesn't shift when you are painting on it.

8. Place the contact paper-backed velvet on the homosote board and secure it along all the edges with masking tape. Take care not to have tape cover more than a half inch of velvet as it can pull out the nap. Place it on the board so the nap feels smoothest as you draw your hand from top to bottom.

9. Be sure to remove any loose fuzzies or lint and nap from the velvet. A loop of masking tape patted gently on the velvet is a good way to remove lint.

Procedure for Theorem Painting on Velvet

1. Now it is time to mix your paints. Since more than one color appears on each Mylar stencil, mix the entire palette of colors before beginning to paint. Very little pigment is needed; indeed, it is surprising how little is actually used. With the palette knife cut off from the tube an amount about the size of a pea of the color to be used and put it on the palette paper. For large theorems the amount of paint can be doubled. Since this is oil paint with no medium, the pigments will keep several weeks when covered, if the piece hasn't been completed at one sitting.

When mixing colors—for example green—and you

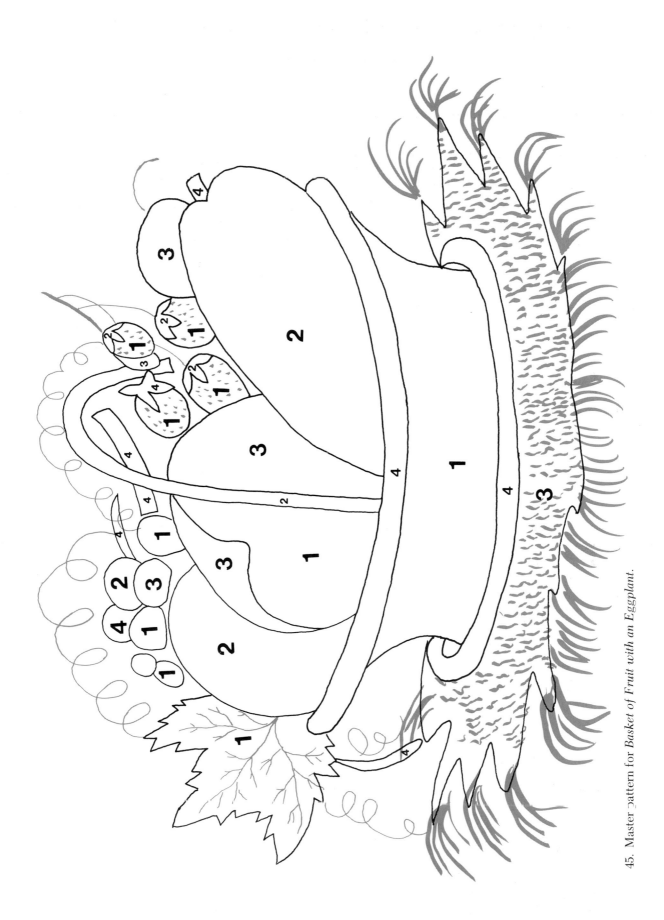

45. Master pattern for *Basket of Fruit with an Eggplant.*

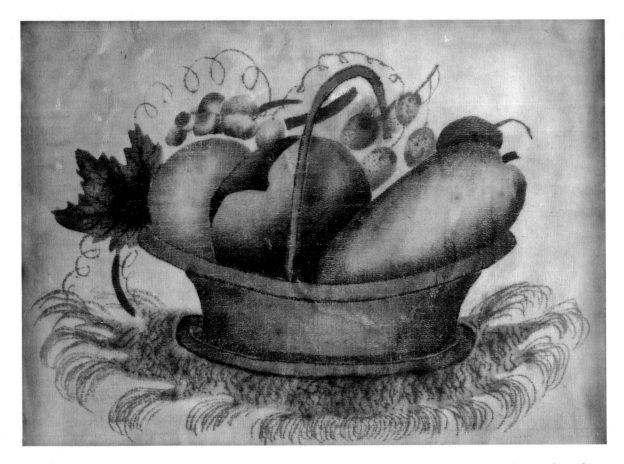

46. This simple *Basket of Fruit with an Eggplant* is an excellent beginner's piece, and it has been selected to illustrate step by step the execution of a theorem painting. 8½″ x 11″. (Collection of H.S.E.A.D.)

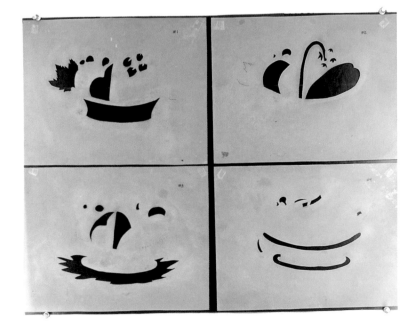

47. This illustration shows the four stencils cut from Mylar during the preparation for executing the theorem.

SCOTCH TAPE
OVER CUT

THEN RECUT
STENCIL

48. Mylar stencils can be easily repaired.

see that there is a lot of it that must be used in the theorem, take care either to mix enough, which can be gauged with experience, or keep a record of how you mixed the color. That way the color can be mixed again if needed. Consult the color instructions for each theorem on velvet.

It is often true that units that appear to have been stenciled white are actually the natural color of the velvet or paper. White was used sparingly in theorem painting.

It is advisable for beginners to reproduce the color chart in this book. This will give the beginner a feel for how much color to apply, the shading that can be achieved, and the true colors that have been mixed.

2. It is important to use a different brush for each color, for it is very difficult to get all the color worked out of a brush. The brush can't be cleaned in turpentine and then used immediately, for the turpentine will stain the velvet and produce messy results. Brushes have to air dry after having been cleaned with turpentine.

3. Place and pin the #1 Mylar stencil on the velvet and on the homosote board, being careful that it is placed on the velvet over the contact paper backing.

4. Cut a 2-inch by 3-inch piece of Mylar to use as a shield. There may be two units that are quite close together. By blocking one area with the Mylar shield the paint will be confined to the area where it belongs.

5. As a general rule, it is best to begin with the lightest color on a stencil. For example, apply all the Naples yellow on stencil #1 first. Then, switching to a new brush, work in the next color that is darker and proceed until all the units on stencil #1 are filled in.

Choose the initial color on stencil #1 and dab the brush in the pigment. Then, rub it off in a circular motion on scrap paper until it appears almost dry. If the brush is wiped out on newspaper it will pick up the ink; if paper toweling is used, the brush will pick up the fuzzies; so use typing or tablet paper.

When applying the paint, an area can always be darkened, but if too much paint is applied initially, it can't be lightened. The intensity of the color is determined by the amount of pressure used. Lightly fill in the cut-out unit, brushing from the top of the unit down. Notice how quickly the nap will pick up the color if the color is brushed up against the nap. On some units this is a desirable effect. Finish putting the first color on the #1 stencil. Choose the next deeper color and complete all those units on the #1 stencil, and continue until all the units and colors have been completed.

6. Continue in the same fashion and complete each of the stencils of the theorem, taking care that the theorem stencils are pinned accurately and securely. When placing the #2 stencil, it will become obvious why it

was necessary to key or dot in a few large units from the #1 stencil. They make it much easier to place each succeeding stencil.

7. After completing all of the units on each of the stencils, check to see if there are any thin white areas separating the units. If so, replace the appropriate unit on the stencil, shifting it so that the white area is exposed and fill the area in with color, using the stencil brush.

On several of the patterns, the central vein of a leaf is created by holding a piece of Mylar in position and shading color off of the edge of the Mylar.

Another technique that is used on a few of the patterns is overstenciling. To create additional detail, the overstencil is applied to an area that has already been painted.

8. Many of the theorems pictured in this book have fine freehand brushwork that adds detail to the painting. This is achieved by mixing a few drops of turpentine with the pigment and loading the brush by twirling it into a fine point. Practice doing this on a scrap of velvet, as many a theorem is ruined at this stage by using too much turpentine and having a stain appear instead of a fine line. On the practice scrap check the back of it to see if there is a turpentine stain. If so, too much turpentine has been used.

When painting the lines with the fine-point brush, hold the brush perpendicular to the velvet and work from the top to the bottom whenever possible, taking care not to work against the nap. Another hint is to make a mental picture of the leaf vein or curlicue and then paint it. Don't start using the fine-line brush, and then stop to check the original, and then continue. Doing so gives a very contrived hesitant look to your work instead of the flowing line that is generally found on the originals. Don't forget to sign and date the work in an inconspicuous spot.

9. After a few days, carefully remove the contact paper from the back of your theorem. If it is removed too fast or too soon, a "spray" of pigment can occur. It is best to lay it right side down on a flat surface and slowly pull the contact paper back while holding down the velvet. Some types of contact paper, such as those with wood-grain patterns, have more adhesive than others. Avoid using those to back the theorem as they can pull out the nap. Instead, use one that is just mildly adhesive.

10. Allow the theorem to air dry several days. Hanging the theorem is a good way of drying it, for it allows maximum air flow. The reds and the blues take much longer to dry than the other colors. The drying time is also affected by how much pigment you have applied.

11. Clean your brushes thoroughly in turpentine, wiping them on a soft rag, then wash in soap and water. Stencils do not usually need to be cleaned, but if there

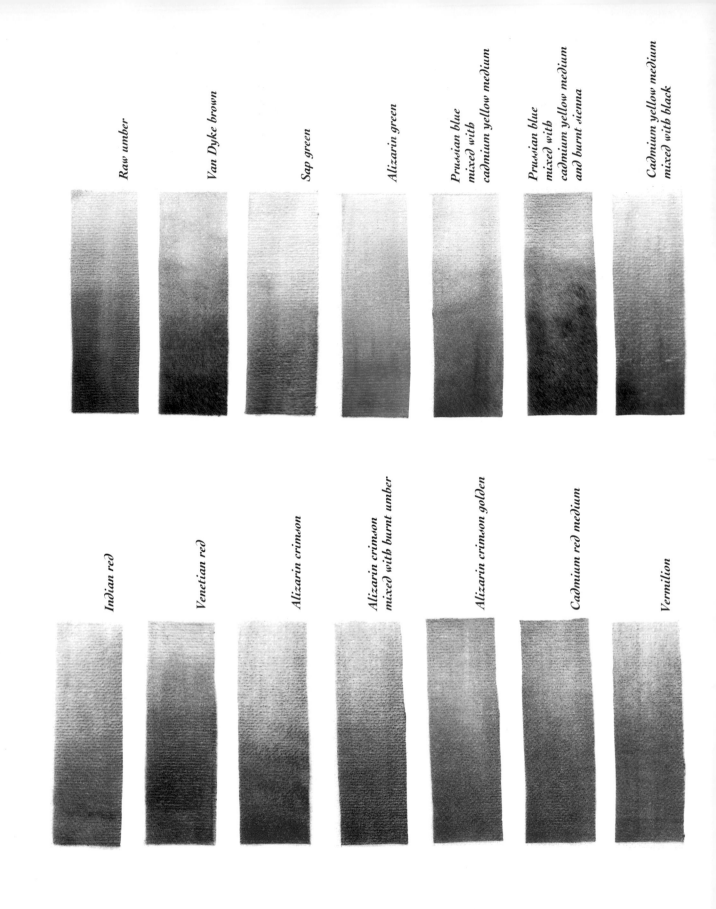

Raw umber

Van Dyke brown

Sap green

Alizarin green

Prussian blue
mixed with
cadmium yellow medium

Prussian blue
mixed with
cadmium yellow medium
and burnt sienna

Cadmium yellow medium
mixed with black

Indian red

Venetian red

Alizarin crimson

Alizarin crimson
mixed with burnt umber

Alizarin crimson golden

Cadmium red medium

Vermilion

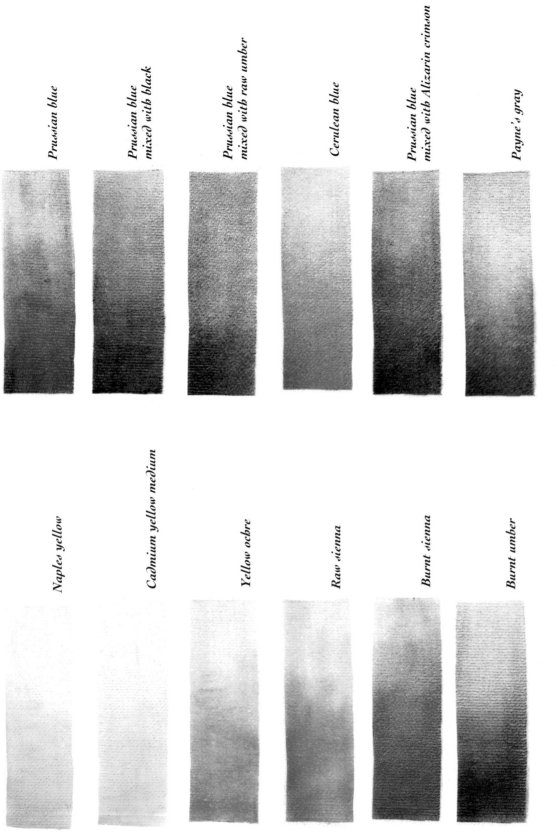

Prussian blue

Prussian blue mixed with black

Prussian blue mixed with raw umber

Cerulean blue

Prussian blue mixed with Alizarin crimson

Payne's gray

Naples yellow

Cadmium yellow medium

Yellow ochre

Raw sienna

Burnt sienna

Burnt umber

49. Color Chart

43

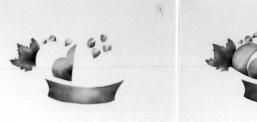

PINS INTO HOMOSOTE · · · · · · · STENCIL

CONTACTE · · · · · · · VELVET

PAPER ————— HOMOSOTE BOARD

50. It is important to line up the velvet and contact paper as illustrated.

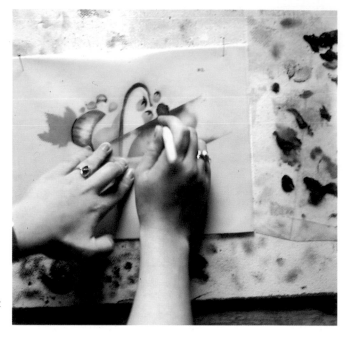

51. A shield of Mylar helps to cover adjacent stencil openings when you are painting.

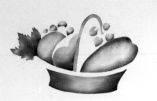
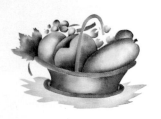
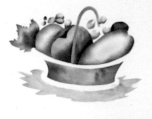

52. This illustration shows the four steps completed on the velvet painting.

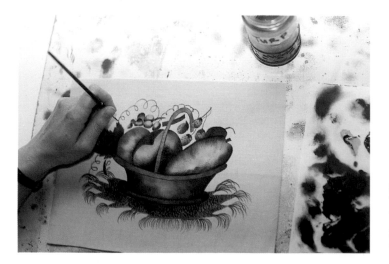

53. Details are put on the theorem painting with a finepoint brush dipped in turpentine and pigment. Rolling the tip of the brush and not overloading it with turpentine is extremely important. If stains appear on the back of the velvet where the turpentine has bled through, then too much turpentine was used.

is a paint buildup on the edges, carefully wipe them with a soft cloth dipped in turpentine. Care must be taken because thin sections of stencil or areas like leaf edges can be easily torn if the cleaning process is done too vigorously. Store the clean stencils between cardboard in a flat area when not in use. Do not roll.

Finishing a Theorem on Velvet

1. Velvet can be "antiqued" either prior to the painting or when the theorem has been completed and the paint has dried. The "antiquing" process makes the background of the completed theorem resemble the discoloration of the old velvets that are seen today in museums and private collections. This discoloration or foxing will be discussed in the chapter on what to look for in an antique velvet theorem. "Antiquing" doesn't change the color of the paint on the velvet. It bonds with the cotton in the velvet, and where your pigments are semitransparent, it appears to give them an antiqued appearance, when actually it is just the fabric that is changing color. If you decide to dye the velvet before you begin painting it, it is important that the velvet be completely dry after it has been dyed, and then you must steam press it on the wrong side. Magic Size can be used when pressing on the wrong side to give the dyed velvet some body before you start painting.

Note that it takes considerable fortitude for the first time to immerse a finished theorem into the brackish pot of dye that has been concocted. The dye always appears darker on the velvet when it is wet. Keep in mind that the dye can be partially rinsed out, without affecting the painting, if it appears too dark. Try it! The effect may be pleasing, and if not, just rinse it out.

A variety of "antiquing" methods can be used. Strong tea will give a mellow yellow color. Strong coffee will give a brownish hue. Black-walnut water will give a golden-walnut shade. Combinations of any of the above will also give interesting shades. In the early fall, collect black walnuts just before the green husk starts to turn brown-black. PUT RUBBER GLOVES ON and hit the husk with a hammer. Put eight nuts with the cracked husks surrounding them into six cups of water in an old saucepan and bring to a boil. Remove from the stove and allow to cool to room temperature. This is the point at which one discovers that he or she has forgotten to put on rubber gloves and the stain of the walnut juice is permanent. Nothing will remove the stain except time. The moral of the tale is: ALWAYS WEAR RUBBER GLOVES when preparing a natural dye. The pot of water and nuts should be allowed to cool; then strain it and store it in the refrigerator in a *labeled* container. Regardless of which dye is used, the dyeing method is the same. For first-time dyers it would be wise to mix up each of the dyes and try them on samples of velvet to see which one is the one you want to use.

When ready to "dip" the thoroughly dry painted velvet, choose one of the following recipes for dye:

½ cup black-walnut water 2 regular teabags 2 cups tap water	(or)	2 cups strong tea (4 or 5 bags)	(or)	2 cups strong coffee (4 teaspoons instant coffee)

Bring each mixture to a full boil. Remove it from the stove. Scrunch the velvet and wet it thoroughly in the dye. Do *not* wring it out. Lay it *flat* on old turkish towels. Do *not* hang it on a clothesline as the dye will sag and dry unevenly. Allow it to dry thoroughly. If for some reason the velvet looks too dark, rewet the velvet in a sink of water and some of the dye will soak out. It really is best to run a test sample of velvet in the dye to arrive at a shade that is satisfactory to you before trying to dye your painting.

It is important to realize that the dyeing does not actually change the color of the oil paints. Because the paints have been applied in a semitransparent manner, the areas of velvet that are not opaque with paint accept the dye and appear to have changed color. The dipping method of aging theorems is preferable to purchasing a tinted or colored velvet. The spotting or foxing can be controlled rather than having an even, all over, aged appearance. Using black walnuts in the dye mixture most closely imitates the antique color of the old theorems.

2. Steam press the theorem on the wrong side after it is completely dry. Use Magic Size spray, available in the household section of the grocery store, on the wrong side of the velvet when ironing it. This restores to the velvet some of the body that has been washed out. Do *not* use spray starch, for it will stain the velvet. *Never* iron the right side of the velvet.

3. Choosing a frame is very important, for it can make or break the final effect of the theorem painting. During

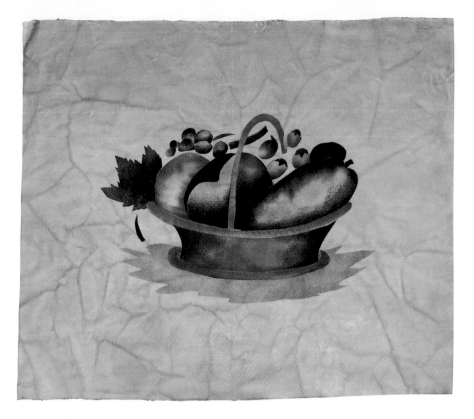

54. A velvet theorem can be instantly "aged"—after the paint is completely dry—by dipping it in a solution of natural dye and tea.

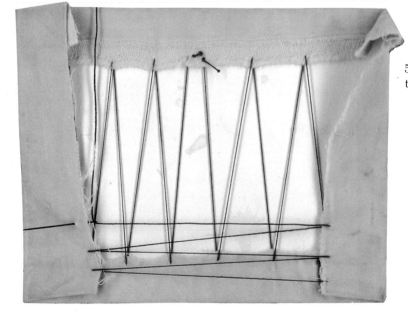

55. A theorem is correctly mounted by lacing the back of the velvet over an archival board.

56. Framing is every bit as important as the painting itself. Spacers are used to keep the painting from touching the glass.

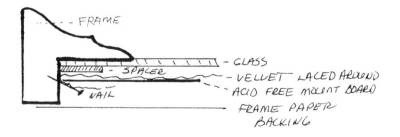

FRAME
GLASS
SPACER
VELVET LACED AROUND
ACID FREE MOUNT BOARD
NAIL
FRAME PAPER BACKING

the 1800s when theorems were first done in America, the materials were expensive, hard to come by, and our forefathers were thrifty. Theorems were framed very closely, oftentimes within an inch of the painting. From a design standpoint, this is a good idea. The theorem will not seem to float around within the frame. The type of frame to be used depends on the theorem. A formal, soft-colored floral theorem will demand an ornate frame, possibly even one with gold leaf. A bold, intensely colored basket of fruit probably would look best in a frame of plain wood, or a wooden frame enlivened with painted graining.

After selecting a frame, take it to have the glass cut. Don't take the measurements, take the frame. More often than not, old or antique frames are not quite square. This hint will save a trip back to the glasscutters. Regular or old glass is to be preferred to non-glare glass because the colors appear much clearer and sharper.

4. Place the glass over the pressed theorem and center it pleasingly. It is usually best to leave a little more blank space between the bottom of the painting and the bottom frame edge, than between the painting and the top. The space on each side should be equidistant to the frame edge when possible.

5. Using a hard-lead pencil, trace around the edge of the glass and remove it.

6. Cut a piece of acid-free mat board, available at framers and art stores, 1/16th inch smaller on all sides than the glass. Sand the edges of the mat board with fine sandpaper to round the edges slightly. Wrap the mat board with cotton muslin. Place the mat board under the theorem, having the edge of mat board and the pencil line on the theorem correspond.

There are a number of ways to mount theorems, from spray adhesive to white glue. None of the methods remains stable over a long period of time in modern home climates. Glues and tapes dry out and cause bubbling.

7. The majority of antique theorems that have remained stable over the last 150 years have been laced. This lacing method is what conservators recommend for mounting a newly completed velvet theorem. They are adamant that textile techniques should be used with textiles. Avoid glues, tapes, and spray mounts at all costs.

Using small pieces of masking tape, wrap the theorem around the mat board on the top and bottom of the back, taking care that the pencil lines are on the edge of the muslin-covered acid-free mat board. Starting in the center of the bottom, lace the theorem from the center out, from top to bottom, keeping pencil lines on the edge of the mat board. Lacing can be at 1-inch intervals. Remove the tape. Proceed in the same manner, taping the sides, then lacing back and forth, starting in the center of the sides. You can pull this lacing fairly taut, as it will be flat when nailed into the frame.

8. Conservators recommend placing six-ply acid-free strips as spacers on top of the glass, along the rabbet of the frame so that the theorem doesn't touch the glass.

9. Be sure that the glass is clean and that the theorem is free of all lint. Nail the theorem into the frame. Use very thin 1-inch-long finishing nails, several on a side, depending on the frame size.

10. To back your painting, take a piece of brown kraft paper of the type used for paper bags that is slightly larger than the frame and soak it in water. While it is immersed run a bead of white glue along the outside edge of the back of your frame. Run a finger over the bead of glue to flatten it. After shaking out the excess water, lay the wet brown paper over the back of the frame on top of the glue. Press it along the edge to be sure there is contact with the glue. Go back and press again a few times at five-minute intervals to ensure the glue bond. Allow it to dry overnight and it will shrink taut. Trim the edges with a ruler and Grifhold knife. Put screw eyes in the edge of the frame about one quarter of the distance from the top of the frame, on both sides. Add picture wire, and your theorem is ready to be hung.

11. Note that an accelerated effect of aging will occur if a newly completed theorem is hung in direct sunlight, over a heat vent, near a wood stove, or in a room where the humidity or pollution is higher than normal, such as in a kitchen. When ready to hang a painting on the wall, take a moment and check the height. Short people invariably hang their paintings far too high for themselves to enjoy. A painting should be hung at the eye level of a person of average height standing in the middle of a room. Put a piece of cellophane tape where the nail is to be pounded. It will prevent the plaster and paint from chipping.

Preparation for Theorem Painting on Paper

1-6. Follow steps 1–6 for painting on velvet detailed on page 38.

7. Cut the paper 1 inch larger on each side than the size of the glass.

8. Secure the paper on heavy smooth cardboard with masking tape so it won't shift while you are stenciling.

Procedure for Theorem Painting on Paper

1. Step 1 is the same as that in the Procedure for Painting on Velvet. When making a color chart put the colors on Strathmore 400 drawing paper.

2. On the cardboard to which the drawing paper is taped (Step 8 of Preparation for Theorem Painting on Paper) use small pieces of masking tape to affix the #1 Mylar stencil to the drawing paper, taking care that placement is centered on the paper.

3. Cut a 2-inch by 3-inch piece of Mylar to use as a shield.

4. Begin with the lightest color on stencil #1. Wrap a 3-inch square of velvet, with the nap toward the outside, around the index finger, holding it in place with the middle finger. Dip the pad of the velvet-covered finger into pigment and rub it out on the palette paper to distribute the pigment on the velvet finger. Start to rub gently in a circular motion from the Mylar onto the drawing paper. The pores of the drawing paper will fill up quickly, and the colors will be mellower than they are on velvet. More paint will not darken a unit, as it does on velvet. If a more intense color is desired, mix a deeper value and apply it where desired. Continue in the same manner and complete each of the units on the #1 stencil and on the succeeding two stencils.

5. After completing all of the units on each of the stencils, check to see if there are any thin white areas separating the units. If so, replace the appropriate stencil, shifting it so that the exposed area can be filled with color.

6. The fine-line work is completed on paper in the same way as it is on velvet (see Step 8 in Procedure for Theorem Painting on Velvet). Practice this technique on drawing paper before completing it on the paper theorem. Errors cannot be removed.

7. Allow the theorem to dry for several days.

8. Clean the liner brush thoroughly in turpentine. Carefully wipe off stencils with a soft cloth dipped in a tiny bit of turpentine. Store the stencils flat when not in use.

Finishing a Theorem on Paper

1. Choose a frame that is appropriate for the paper theorem. Most old theorems were framed quite close to the edge of the painting so keep that in mind when choosing a frame.

2. Have the glass and acid-free mat board cut to fit the frame.

3. Place the glass over the theorem and center it pleasingly. Mark it with a pencil.

4. At this point the paper theorem can be "aged" by placing it on a cookie sheet in a 325-degree oven for approximately ten minutes. The rag content of the paper will discolor and will give the paper an "aged"

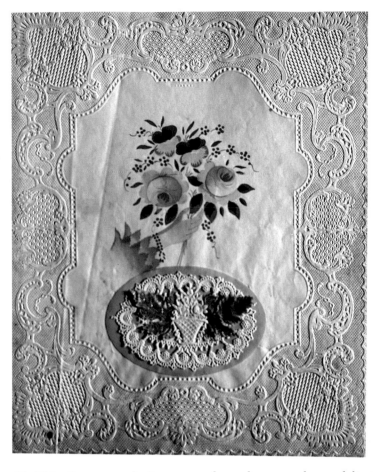

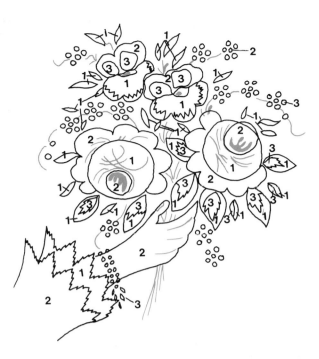

58. Master pattern for the theorem valentine.

57. This theorem valentine on embossed paper shows delicate stenciling and brushwork, and it is the example used for the step-by-step directions for theorem painting on paper. (Collection of Helene Britt, H.S.E.A.D.)

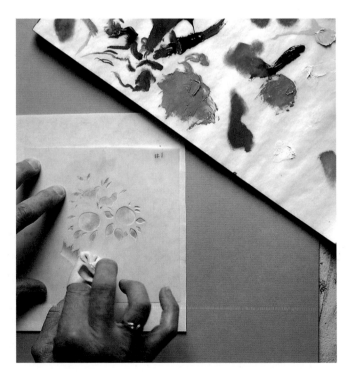

60. This illustration shows the method for wrapping a finger with velvet to apply paint to paper. It is important to hold the velvet with the middle finger so that the index finger can move freely.

59. This illustration shows the stencils cut from Mylar for the theorem valentine on paper.

appearance. It is wise to put a test strip in the oven to check for the length of time and heat setting since everyone's oven is different. Be sure not to allow any of the paper to hang over the edge of the cookie sheet, for it will darken unevenly.

5. After "aging" the paper theorem, cut along the pencil lines. Take care in doing this, for the paper will have become brittle in the "aging" process. Place the paper theorem over the clean glass.

6. Place the acid-free mat board cut to the size of your glass on top of the paper theorem and proceed as in step 9 of Finishing a Theorem on Velvet.

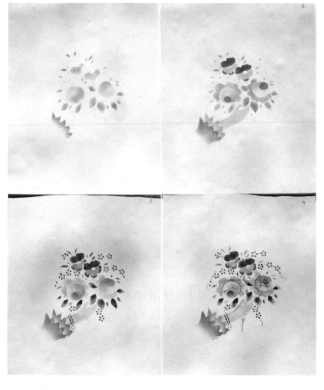

61. This illustration shows the step-by-step theorem painting of the valentine on paper.

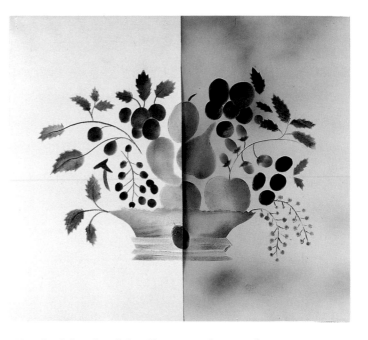

62. The left side of this illustration shows a theorem on paper before baking it to give it an "aged" look. The right side of the illustration shows the paper theorem after it has been baked on a cookie sheet at 325 degrees for approximately ten minutes.

Patterns

Included on the following pages is a selection of different patterns that can be used for a variety of projects. These vary in difficulty, design, and surface, some having been done on paper and others on velvet. Every effort has been made to give directions that will enable a successful re-creation of the antique theorem that is illustrated. It is important to remember that the directions are, of course, given for the theorem as it appears today. Some colors are fugitive and thus have changed over the years. Note that we give the size of the original theorem and whether or not the master pattern has been reduced to fit the format of this book. If the pattern has been reduced, the percentage of reduction has been noted. Take the master pattern in the book to a local copier and have it copied and then enlarged, if necessary, to the size of the original painting. For example, if it is noted that the pattern has been reduced to 87% of the original, then have your copy of the master pattern enlarged by 113%. When you are enlarging a pattern, begin with the figure of 100% (the size of the master pattern as it appears in this book) and add the percentage by which it has been reduced. Then continue with the directions given under the sections called **Preparation** and **Procedure**.

Peach and Pear

Note: This theorem on velvet from the collection of Doris Fry, H.S.E.A.D., although not particularly well cut, is a good beginning theorem to execute on velvet. The master pattern is full size.

Colors to be used:

Naples yellow—use on the peach, on the entire pear and currants.

Yellow ochre—use where yellow is deeper in hue on the pear.

Orange—combine cadmium red medium with vermilion and burnt umber. Use on the left side of the peach and cherries.

Green—combine Prussian blue with cadmium yellow medium and raw umber. Use on all leaves and veining.

Blue—combine Prussian blue with black. Use on the grapes and plums.

Burnt umber—use on the stems.

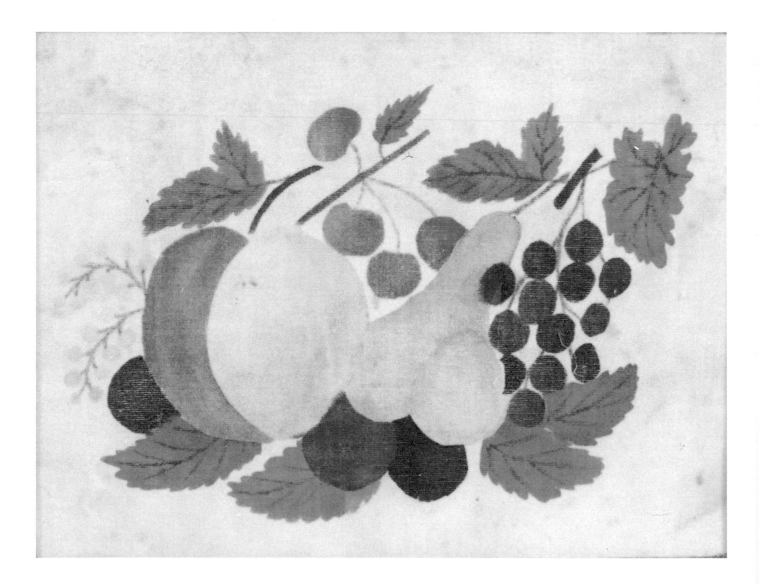

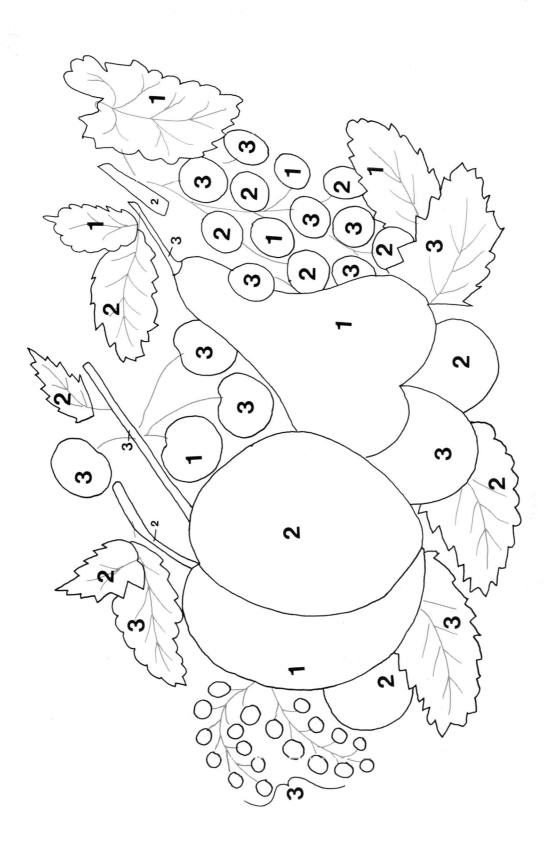

Southern Rose

Note: This theorem on paper from the collection of Helene Britt, H.S.E.A.D., has lettering and flourishing inside the cartouche that is done freehand. The master pattern is full size.

Colors to be used:

Cadmium red—use on the rose.

Green—combine Prussian blue with cadmium yellow medium and black. Use on the leaves.

Black—use on the veins.

Pink—combine cadmium red medium with white. Use on the cartouche surrounding the writing.

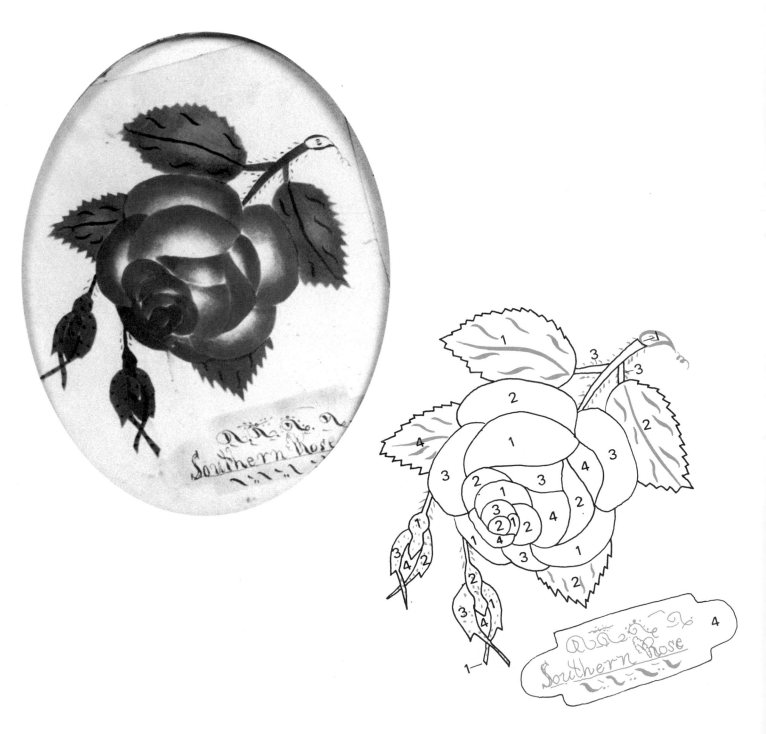

Pincushion Shells

Note: The four theorems on velvet that decorate these pincushions from the collection of Mary Sanford and Helene Britt, H.S.E.A.D., are extremely easy to make. Be careful, when placing the theorems on the velvet, to allow enough space around each theorem so that you can easily separate each theorem from the other three. The master patterns are full size.

Colors to be used (from left to right):

A) *Red*—Alizarin crimson combined with cadmium red medium and white. Use on the roses.

 Green—cadmium yellow medium combined with Prussian blue and black. Use for the fineline details.

B) *White*—use on white flowers.

 Green—cadmium yellow combined with Prussian blue and burnt sienna. Use for the fineline details.

C) *Orange*—vermilion combined with white. Use on the flower.

 Yellow—cadmium yellow medium to be used in the flower center.

 Red—Alizarin crimson combined with burnt umber and white. Use on the flower.

 Green—cadmium yellow medium combined with Prussian blue and burnt umber. Use on the leaves.

D) *White*—use on the berries.

 Green—cadmium yellow medium combined with Prussian blue and black. Use for the fineline details.

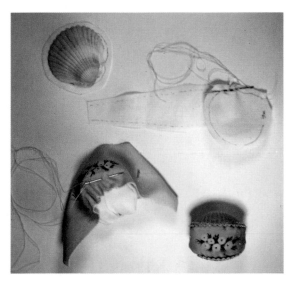

Steps for completing the pincushion shells:

Supplies: Two scallop shells approximately 2½ inches in diameter, which will be the top and bottom of each pincushion. The scallop shells can be purchased at craft or hobby stores. Nine inches of white muslin, 1 cup of fine sawdust, needle and quilting thread, scissors, hot-glue gun, and passepartout tape if desired.

1. Execute the theorem in the center of a strip of velvet that is 2½ inches wide and as long as the circumference of one of the shells you are using.

2. Trace the circumference of the shell on the white muslin and cut out two pieces.

3. Cut a piece of muslin the length of the shell circumference and gusset shaped, i.e. wider at the front of the shell, and approximately 1 inch on either side of the center of the pattern. Baste the gusset to the two shell-shape pieces of muslin, thus making a miniature bag with an opening at the narrow end of the piece of muslin.

4. Turn the bag inside out and fill it tightly with sawdust, and then baste it closed.

5. Lay the theorem on top of the muslin bag and baste it on the muslin ½ inch from the edge of the velvet.

6. Hot-glue the shells to the muslin bag so that the narrow ends of the shells touch each other, and the shells stick to the velvet and to the muslin bag.

7. A narrow strip of gold passepartout paper tape, available from a lampshade store, can be hot-glued to the edge of the shells if desired.

Drawstring Bag with Eagle Motif

Note: This theorem on velvet is from the collection of Helen Spear, H.S.E.A.D. The master pattern is full size. If the velvet painting made from this pattern is actually made into a drawstring bag, be sure to allow plenty of velvet for seam allowances and for a placket to hold a drawstring.

Colors to be used:

Bright yellow—use cadmium yellow medium on the peaches and on the torch.

Yellow—use yellow ochre on all other yellow areas and over cadmium yellow medium on the peaches.

Bright blue—cerulean blue combined with Prussian blue. Use on the grapes and torch.

Light blue—cerulean blue combined with Prussian blue and black and white. Use on the blossoms.

Green—yellow ochre combined with Prussian blue and white. Use on the leaves.

Brown—burnt umber combined with burnt sienna and white. Use on the eagle.

Pink—burnt sienna combined with Venetian red and white. Use on the roses.

Burnt umber—use for all fineline detail work.

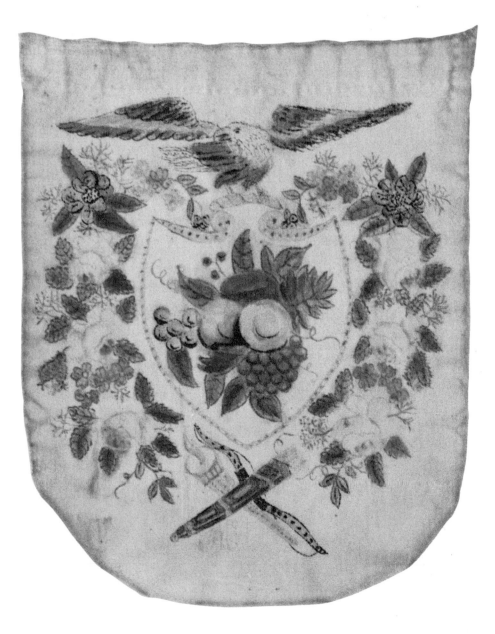

Floral Scroll Dated 1843

Note: This theorem on paper is from the collection of Helene Britt, H.S.E.A.D. The master pattern is full size. Be sure to use a quality of paper that will take fineline work; we suggest Strathmore 400 drawing paper.

Colors to be used:

Pink—Alizarin crimson combined with white. Use on the roses and buds.

Blue-green—Prussian blue combined with yellow ochre and white. Use on open blossoms on the left and on the bottom of the scroll.

Cadmium yellow medium—use on the pansy, sweet pea, and other small units, and on the base of the morning glory.

Burnt sienna—use on the leaf tips, four-petaled flowers and buds, and wherever the color rust appears.

Prussian blue—use on the tip of the morning glory and on the two buds and forget-me-nots on the left side.

Purple—Alizarin crimson combined with Prussian blue. Use on the sweet pea and pea buds and on the pansy.

Green—yellow ochre combined with black and burnt sienna. Use for all the green units and fineline brushwork.

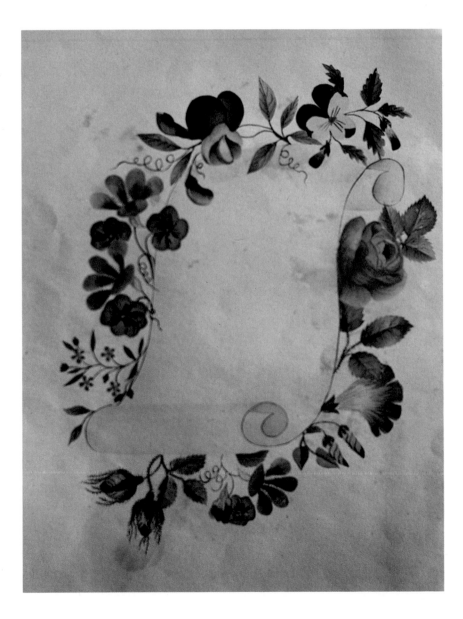

Fruit in Cornucopia

Note: The master pattern has been reduced 13% to fit this book, so enlarge the pattern by 113% before cutting. The fineline detail work on the cornucopia is done with burnt umber; the rest of the detail work is done in dark green. This theorem on velvet is in a private collection; the photograph is courtesy H.S.E.A.D.

Colors to be used:

Yellow ochre shaded with burnt umber—use on the cornucopia, peach, and large stems.

Blue—Prussian blue combined with black and white. Use on the grapes.

Red on strawberries—use Naples yellow underneath and Alizarin crimson combined with burnt umber and white shaded over it.

Reddish grapes—use burnt sienna combined with Indian red and white.

Pears—use Naples yellow combined with burnt sienna and white and with dark green mottled on top.

Dark green—cadmium yellow medium combined with Prussian blue and black and burnt sienna. Use on the melon and leaves.

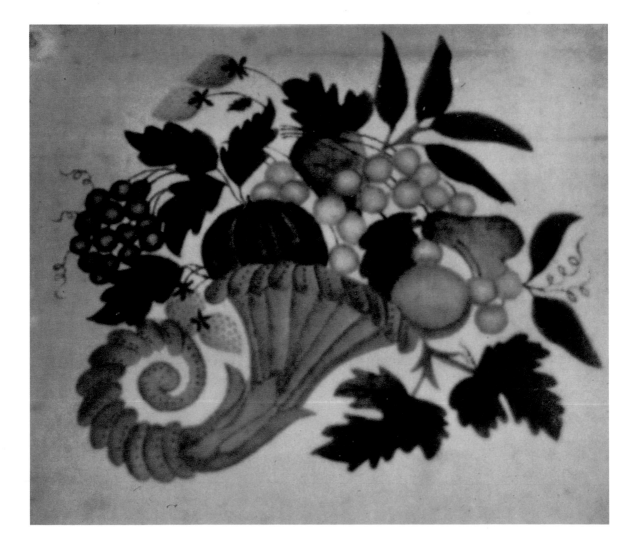

61

Floral Ring

Note: This theorem on velvet is from the collection of Sarah Tiffany, H.S.E.A.D. The cut-out units in this theorem are small, and they will require the use of several small stiff brushes. The master pattern is full size.

Colors to be used:

Cadmium yellow medium—use on the roses, flower centers, flower stamens, small daisies, and leaf tips.

Green—cadmium yellow medium combined with Prussian blue and raw umber. Use on the center of the passion flower and on all the leaves.

Blue-green—mix green as given above and add more Prussian blue. Use on the deeper areas of the leaves and for veining and detail work.

Cerulean blue—use on the bluebells and on the small flowers next to the carnation.

Red—Indian red combined with white for a lighter shade. Use on the peony and the carnation, on the back of the rose, and on the pink buds.

Dark red—Indian red combined with burnt umber. Use for the deeper shade of the peony and carnation and for fineline details on flowers.

Orange-red—Indian red combined with vermilion. Use on the two hanging carrot-shape flowers.

Gray-blue—Prussian blue combined with black and white (more white should be used for the passion flower). Use on the large daisies, the eight-petaled flower, the passion flower, and details.

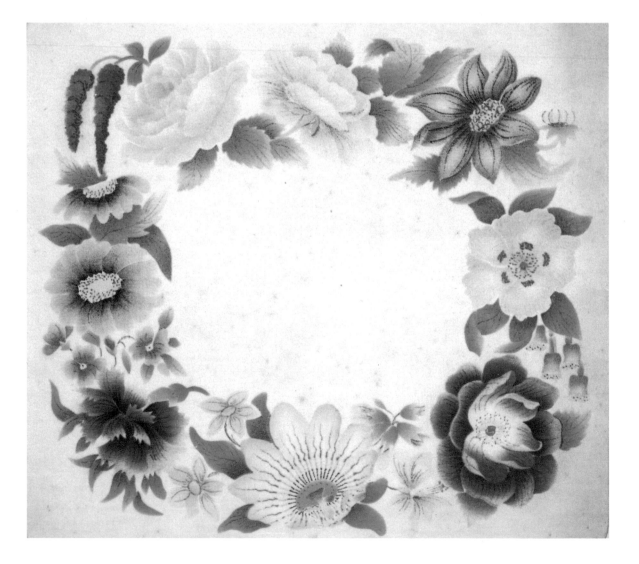

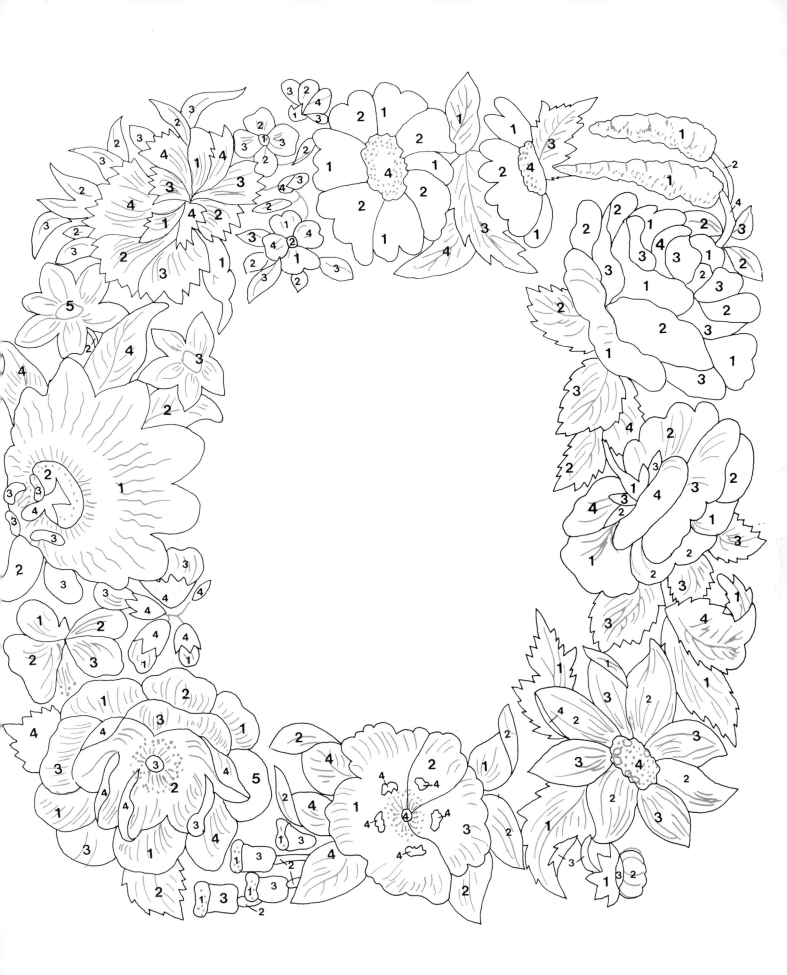

65

Lily Book Cover

Note: This velvet painting from the collection of Helene Britt, H.S.E.A.D., was probably executed freehand. It has been adapted for stencils to resemble closely the original illustrated here. Some of the areas in this painting have no color applied, so the color of the velvet shows through. The master pattern is full size.

Colors to be used:

Gray—black combined with white. Use on the lily petals and buds.

Bright blue—use cerulean blue on the leaves.

Bright green—cadmium yellow medium combined with Prussian blue and raw umber. Use on the leaves.

Dark green—cadmium yellow medium combined with Prussian blue and black. Use on the leaves.

Naples yellow—work in the blossoms where needed.

Burnt sienna—use for fineline details on the wheat, leaves, and pistils.

Burnt umber—use for fineline details on the stamens and grass.

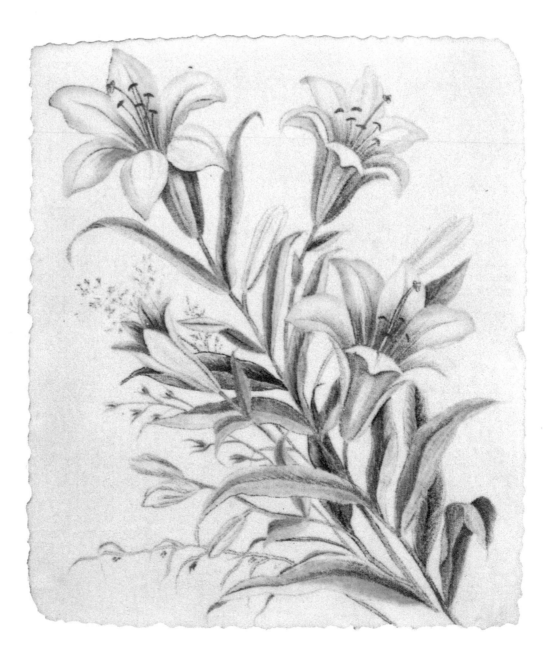

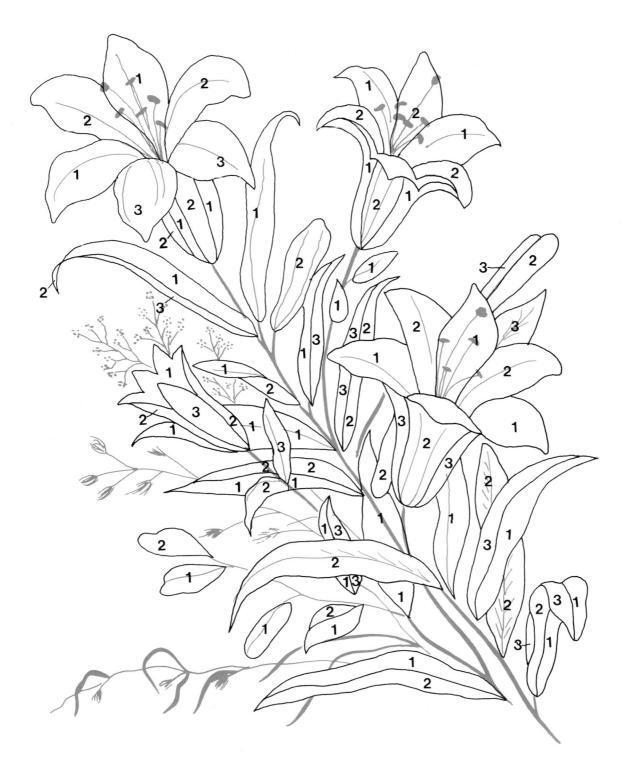

Rose Valentine with Verse

Note: This theorem on bristol board is from the collection of Sally Lovely, H.S.E.A.D. The suggested paper to use is ecru-color parchment paper. The verse should be inscribed in brown ink. The master pattern is full size.

Colors to be used:

Red—Indian red combined with white. Use on the roses and buds.

Green—cadmium yellow medium combined with Prussian blue and burnt umber. Use on the leaves.

Gray—black combined with white. Use on the scalloped oval.

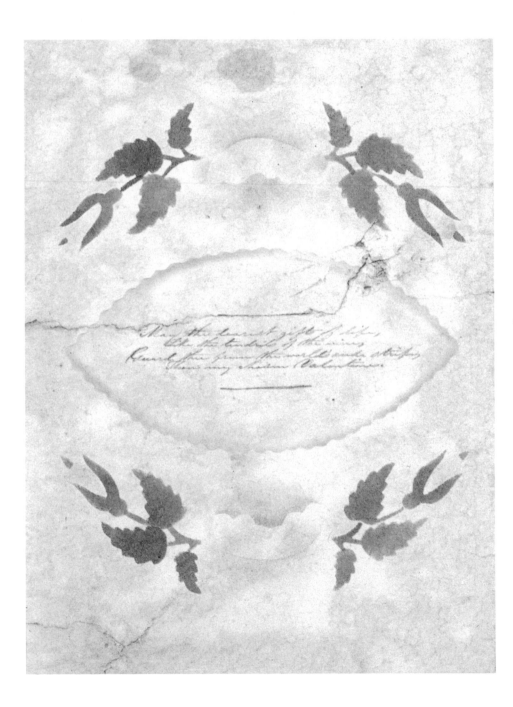

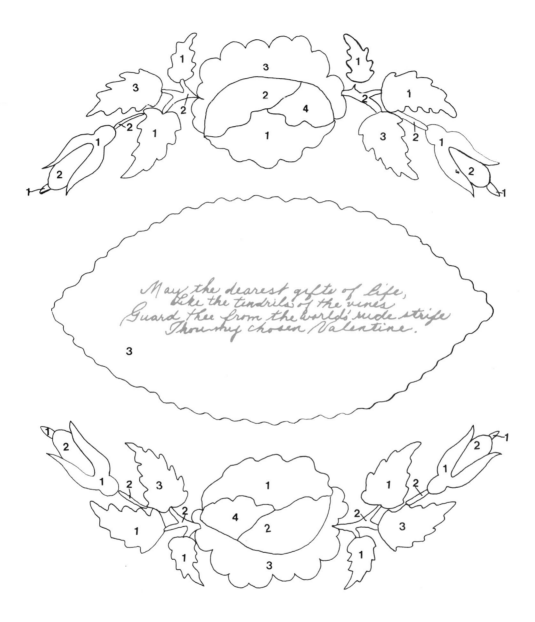

May the dearest gifts of life,
Like the tendrils of the vines
Guard thee from the world's rude strife
Thou my chosen Valentine.

Large Moth

Note: This theorem on paper from the collection of Phil Keegan, H.S.E.A.D., has gold paint on it. If the design is executed on paper, gold acrylic paint can be used. The master pattern is full size.

Colors to be used:

Naples yellow—use under leaves, in daisy centers, on the lower part of the wings above the gray.

Dark green—cadmium yellow medium combined with Prussian blue and black. Use on the leaves and on the large wings near the body of the moth and on the small lower wings.

Blue—use Prussian blue on the daisies and on the fineline detail around the yellow centers on the daisies.

Red—Alizarin crimson combined with burnt umber. Use on the large wings.

Orange—vermilion combined with white. Use on the small lower wing near the body of the moth.

Black—use on the body of the moth, shaded lighter toward the tail and on the edge of the large wings.

Gray—repeated with the edge of the stencil along the edges of the wings. Use for fineline work.

Gold—paint along the black lines on the large wings and along the black wiggles on the smaller wings.

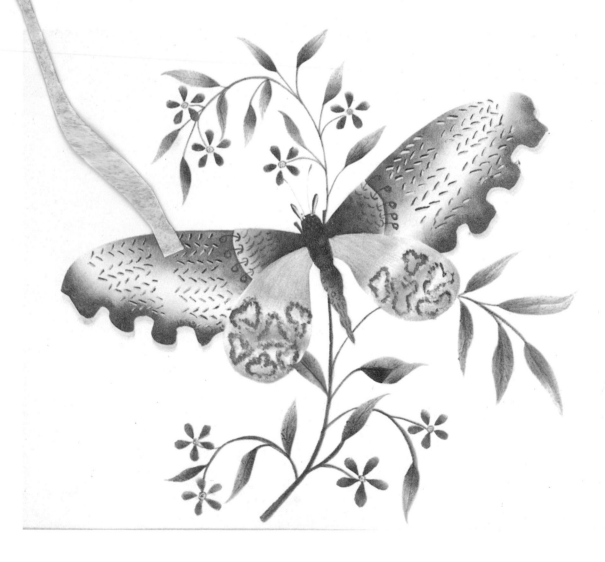

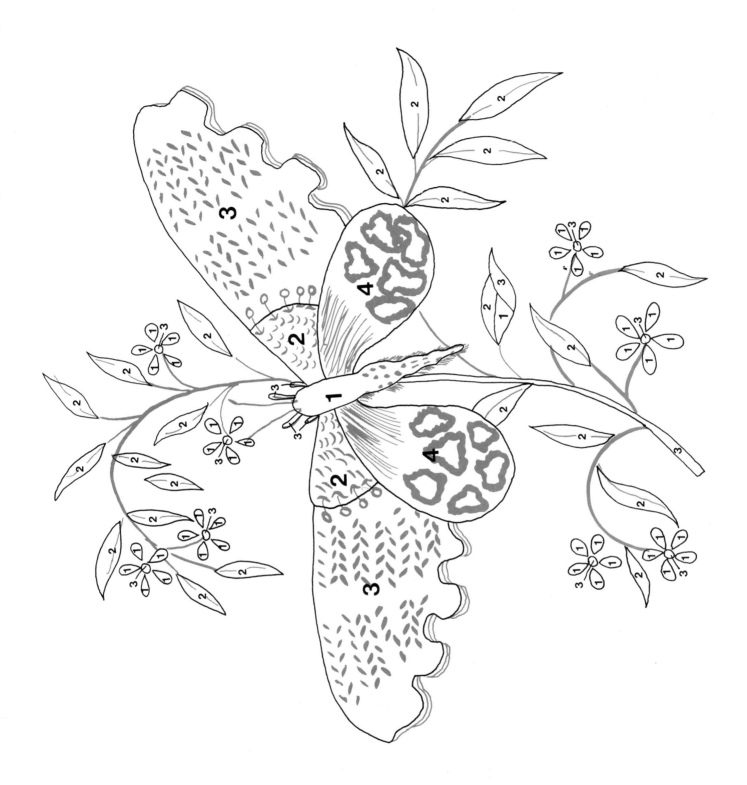

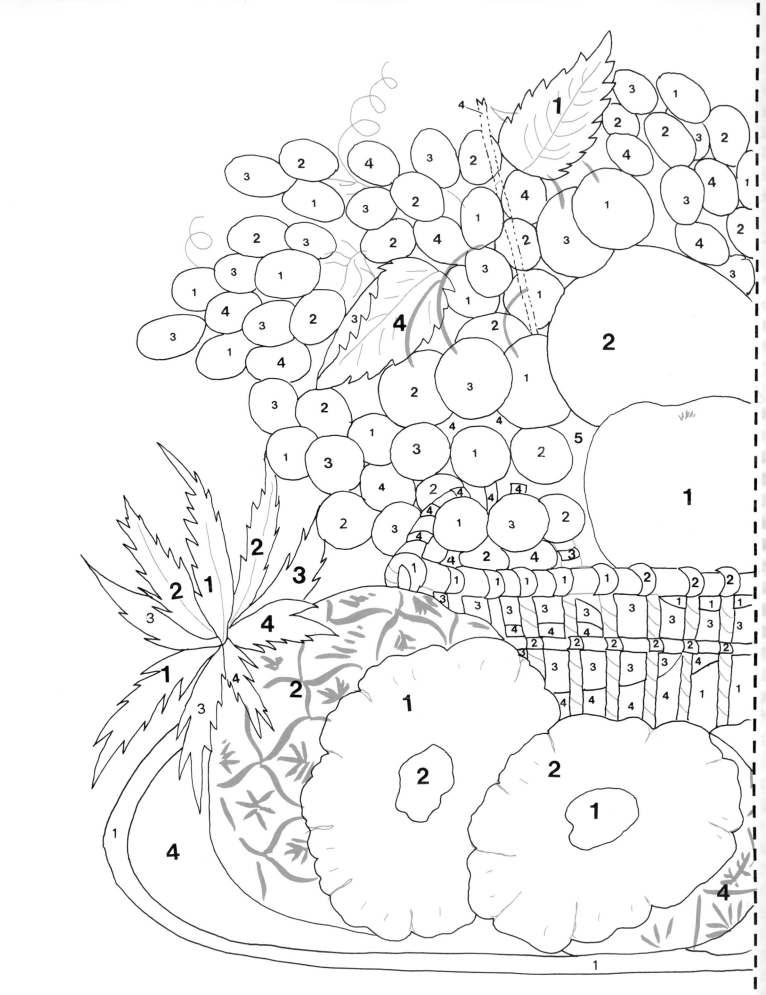

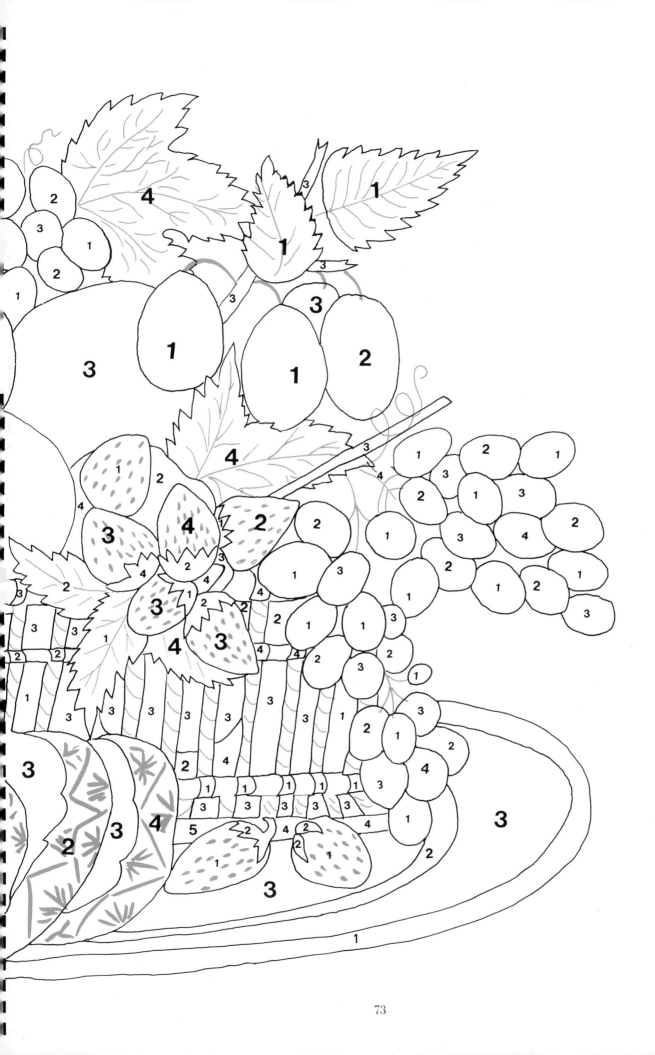

Pineapple in an Open Basket

Note: Much of this unusual and appealing velvet theorem from the collection of Jean Milonas, H.S.E.A.D., was probably painted freehand, but the stencils make it possible to create a theorem that closely resembles the original shown here. The master pattern is full size.

Colors to be used:

Green—yellow ochre combined with black and burnt sienna. Use on the leaves.

Light green—yellow ochre combined with black, burnt sienna, and white. Use on the grapes.

Blue—Prussian blue combined with black and white. Use on the plate.

White—white combined with Naples yellow. Use on the slice of pineapple.

Naples yellow—use on the large fruit with Naples yellow as the basic color and with burnt sienna on top.

Naples yellow shaded with raw umber. Use on the pineapple rind.

Burnt sienna—use on the large plums on the right shaded with burnt umber; use burnt sienna alone on the strawberries, cherries, and assorted grapes.

Gray—black combined with white. Use on the table.

Burnt umber—use for fineline details on the pineapple, basket, tendrils, veins, etc.

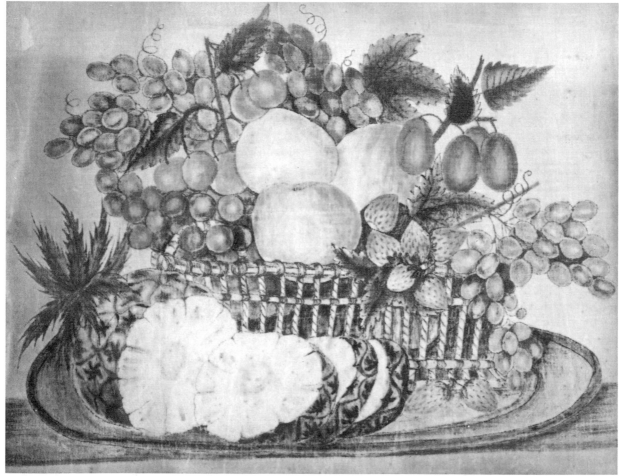

Pattern appears on pages 72-73.

Tulip with Open Roses

Note: This theorem on paper from the collection of Phil Keegan, H.S.E.A.D., would be a good beginner's piece. The master pattern is full size.

Colors to be used:

Yellow—cadmium yellow medium combined with white. Use on the large tulip and on some of the leaves and dots around the centers of the roses.

Pink—Alizarin crimson combined with burnt umber and white. Use on the open rose blossoms and buds.

Red—Alizarin crimson combined with burnt umber. Use on tulips.

Blue-green—cadmium yellow medium combined with Prussian blue and burnt umber. Use on the large leaf.

Green—cadmium yellow medium combined with Prussian blue and burnt sienna. Use on the leaves and stems, and use to create details like the thorns and veins.

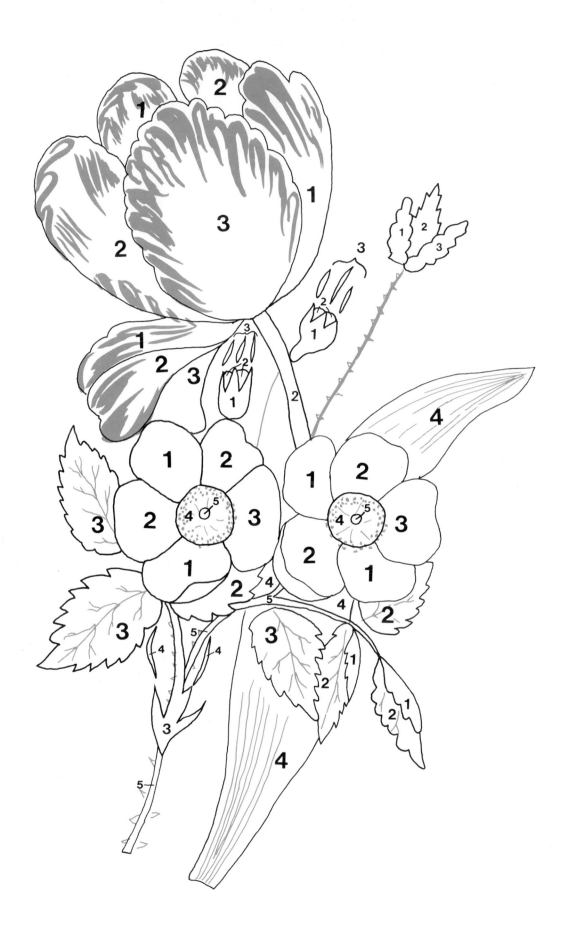

Oval Floral

Note: This theorem on velvet was signed by Laura Taylor in 1846, and it is believed to have been done by her at a girls' school in Mississippi where it was found. It is from the collection of Mary Sanford, H.S.E.A.D. On the master pattern there are two separate patterns for overstencils. Cut the tulip overstencil on a separate square of Mylar and execute after the main theorem is complete. Cut the daisy overstencil on three separate squares of Mylar and execute after the main theorem is complete. The master pattern is full size.

Colors to be used:

Naples yellow—use on the tulip, the center of the large daisy, the small daisies, and buds.

Red—cadmium red medium combined with Alizarin crimson and burnt umber. Use on the large daisy, on the tulip overstencil, and on the morning glories.

Dark red—Alizarin crimson combined with black. Use on an overstencil on the large daisy.

Green—cadmium yellow medium combined with black and burnt sienna. Use on leaves.

White—use on the large white flower, then shade with gray.

Mauve—Prussian blue combined with Alizarin crimson and black and white. Use on the morning glories.

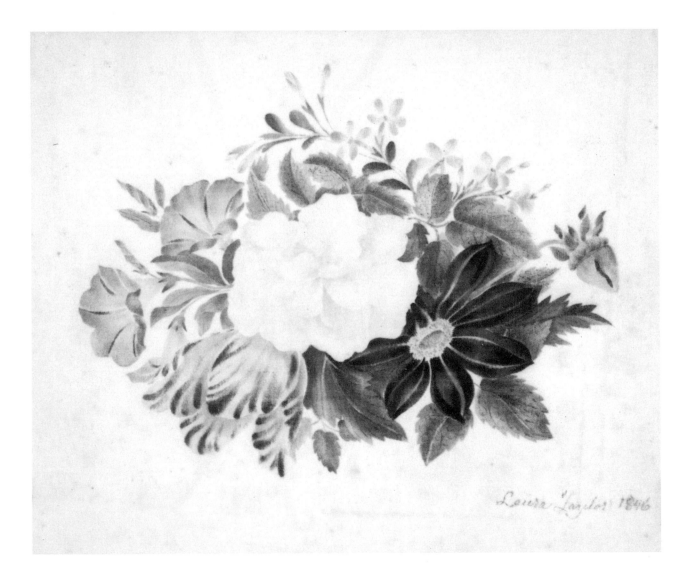

Laura Taylor 1846

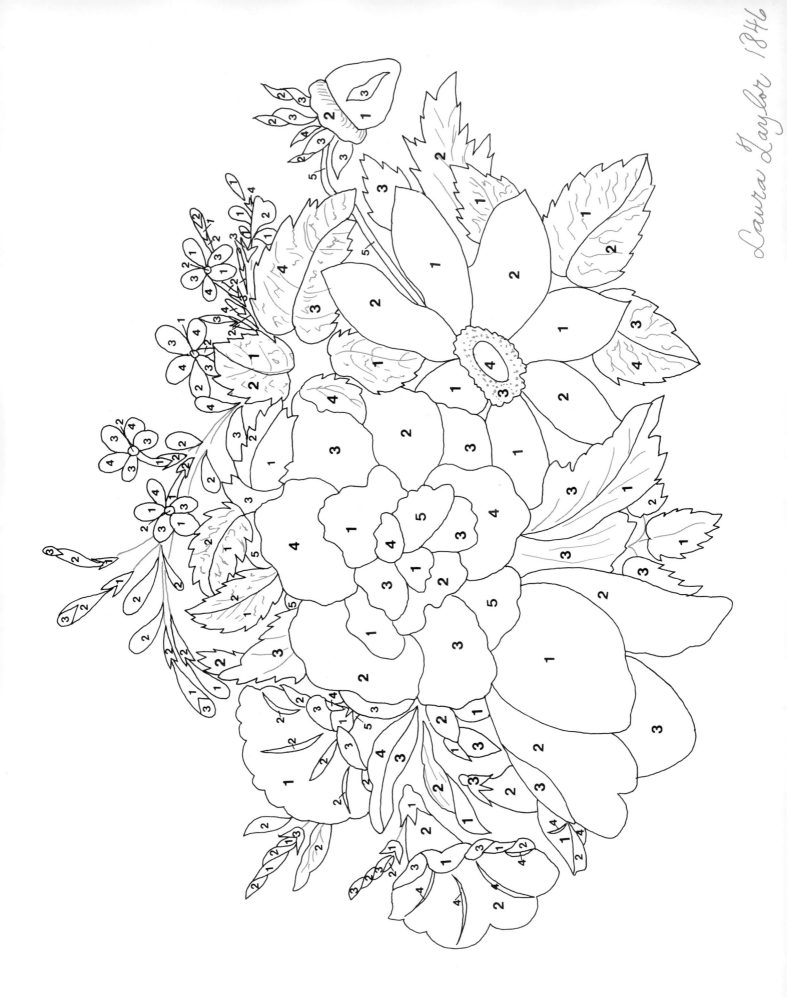

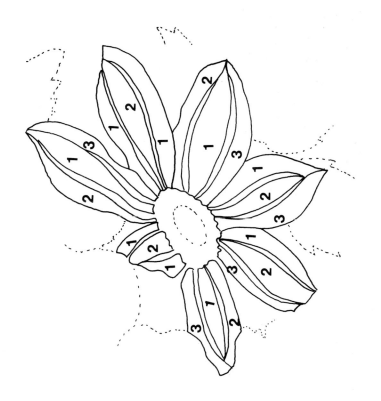

Two overstencils for the Oval Floral theorem

Grapes in a Bowl

Note: This theorem on paper is from the collection of Helene Britt, H.S.E.A.D. The detail and shading on the basket is done in pencil over the yellow background. The master pattern is full size.

Colors to be used:

Blue—Prussian blue combined with black and white. Use on the grapes.

Green—cadmium yellow medium combined with Prussian blue, burnt umber, and white. Use on the leaves.

Brown—burnt sienna. Use on the leaf edges, tendrils, and stems.

Yellow—Naples yellow combined with white. Use on the basket and handles.

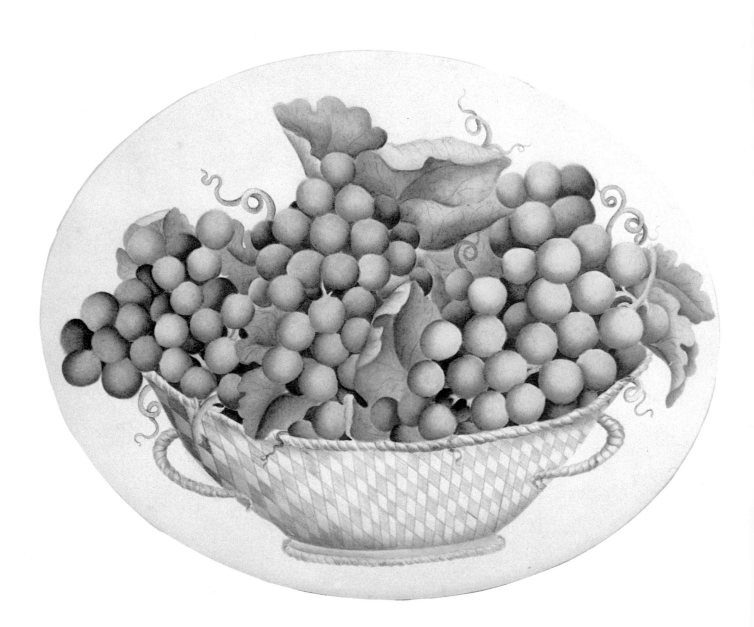

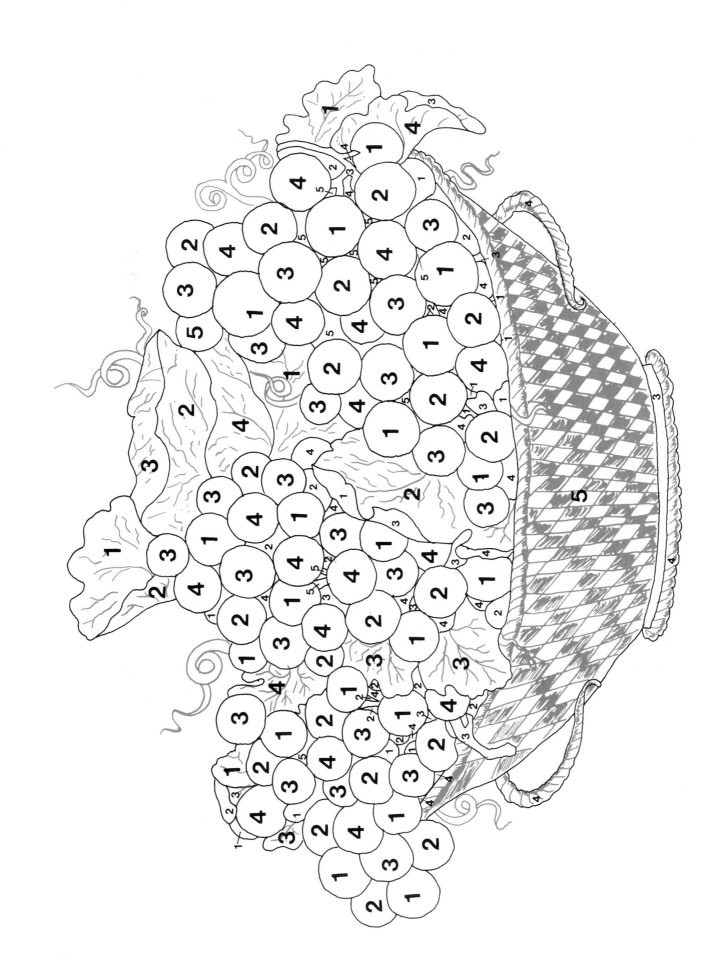

Weeping Tree Rose

Note: This theorem on paper is from the collection of Phil Keegan, H.S.E.A.D. It is a botanical plate from a J.W. Thompson seed catalog. The master pattern is full size. Use Strathmore 400 drawing paper to execute theorem. Coat the entire base of each rose with the appropriate color. Leave the stencil in place and select an appropriate petal stencil. Place the petal stencil according to the dotted line key on the master tracing and shade in the next deeper shade of pink or red. On the dark roses, shade the petals with gray.

Colors to be used:

Light pink—white combined with burnt sienna and Alizarin crimson. Use on appropriate roses.

Medium pink—use the same combination of colors detailed above, but with less white. Use on appropriate roses.

Dark red—cadmium red medium combined with Alizarin crimson. Use on appropriate roses and buds.

Green—cadmium yellow medium combined with Prussian blue and burnt sienna. Use on the leaves, buds, and trunk.

After completing the basic design of the theorem, do green and burnt sienna spongework to fill in the background behind the roses, buds, and leaves.

Add more Prussian blue to the green mixture to do veining and fineline work.

WEEPING TREE ROSE.

J. W. THOMPSON. Fruit and Flower Plates.

Rose 1 - A

Rose 1 - B

Rose 1 - C

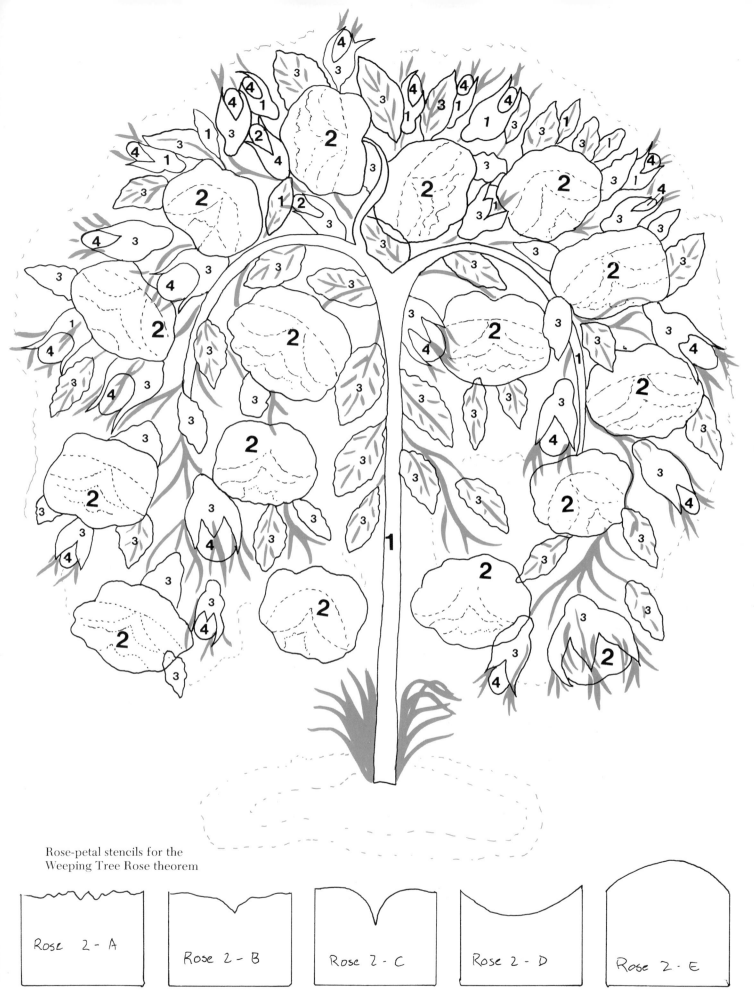

Rose-petal stencils for the
Weeping Tree Rose theorem

Rose 2 - A

Rose 2 - B

Rose 2 - C

Rose 2 - D

Rose 2 - E

Roses and Tulips with Morning Glories

Note: This theorem on velvet is from the collection of Helene Britt, H.S.E.A.D. The master pattern is full size.

Colors to be used:

Raw sienna—use underneath the green on the leaves where appropriate.

Green—yellow ochre combined with Prussian blue and burnt sienna. Use on the leaves over raw sienna.

Light brown—burnt sienna combined with white. Use on the roses and buds.

Blue—Prussian blue combined with black. Use both dark and light blue on the tulips, the morning glories, and buds.

Burnt sienna—Use for the detail work on the three hanging buds.

Burnt umber—Use for the detail work on the leaves.

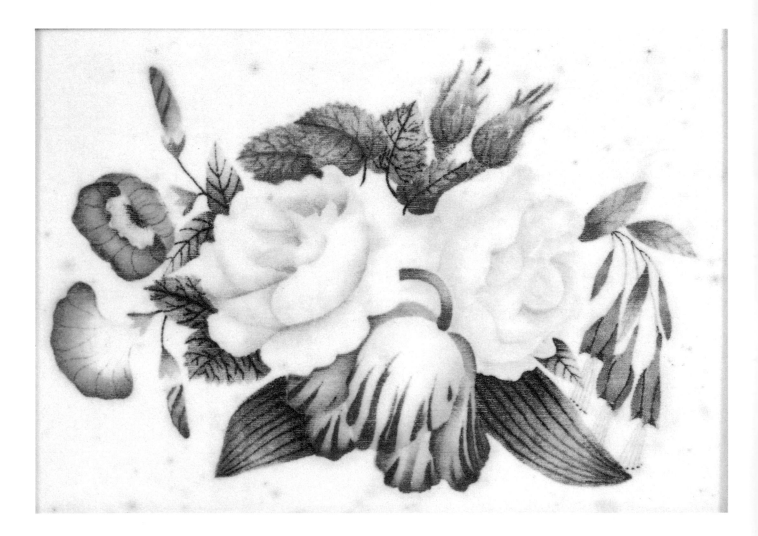

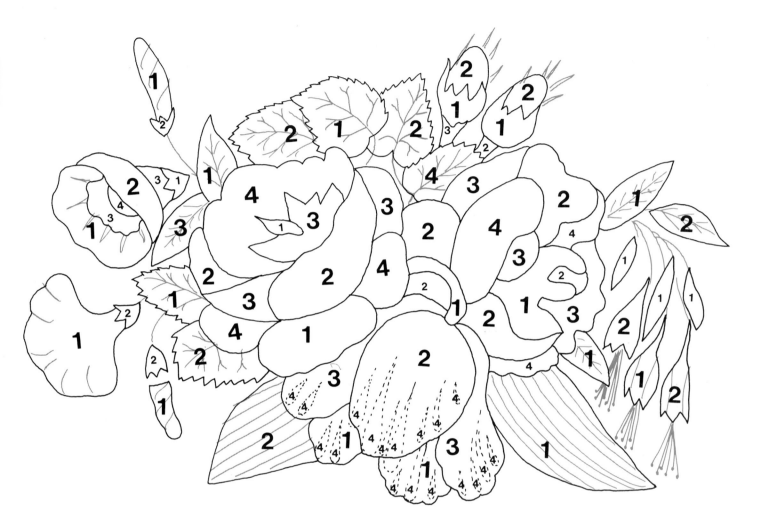

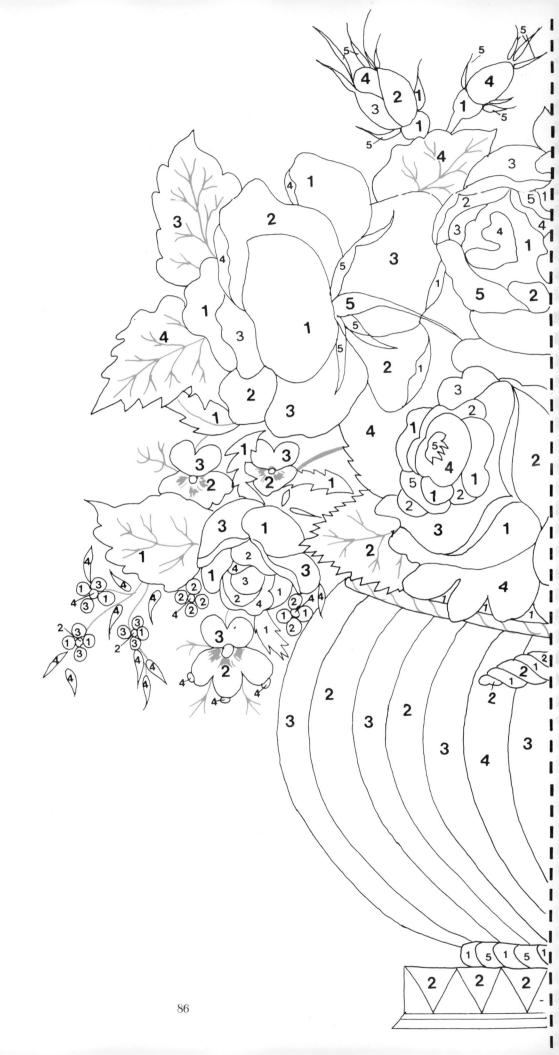

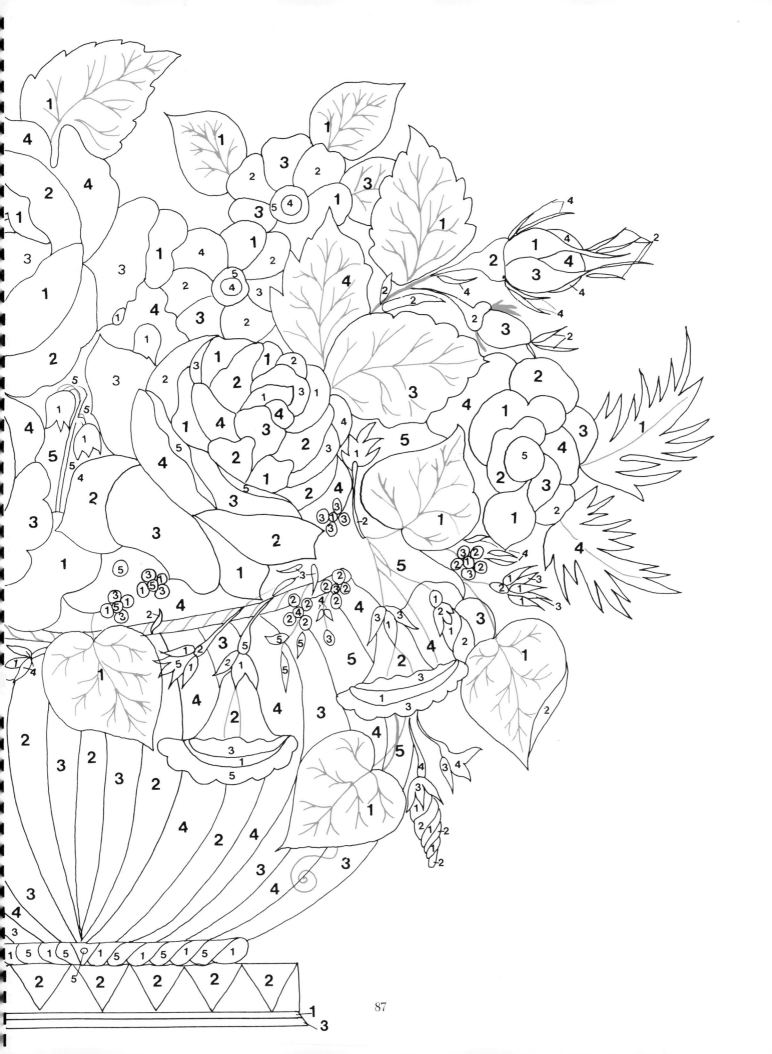

87

Bowl of Roses and Morning Glories

Note: This theorem on paper is from the collection of Jean Milonas, H.S.E.A.D. The master pattern is full size. Use Strathmore 400 drawing paper. Save the cutouts to be used for the forget-me-nots, bluebells, and an occasional leaf edge to lay down over the painted unit as a shield so that the dark area can be painted. When painting the bowl, make sure that the correct side of the unit is being highlighted.

Colors to be used:

Prussian blue—use for all the blues.

Yellow—Naples yellow deepened with yellow ochre then shaded over with gray. Use on the roses and pansies.

Light green—Naples yellow combined with a touch of dark green. Use on the appropriate leaves.

Dark green—Prussian blue combined with burnt umber and cadmium yellow. Use on the leaves.

Red—Indian red combined with vermilion. Use on the bright rose.

Pink—Indian red combined with vermilion and white. Use on the pale rose and the flower on the right.

Gray—use on the bowl.

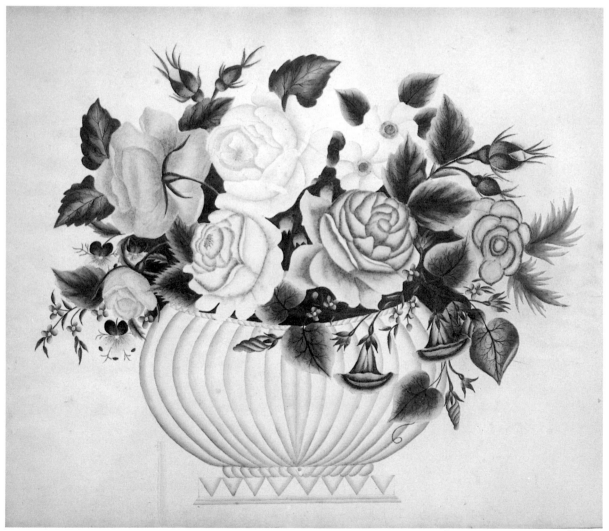

Pattern appears on pages 86-87.

Bowl of Fruit

Note: This theorem on velvet is from the collection of Ruth Flowers, H.S.E.A.D. The pattern has been reduced 25% to fit the book, so enlarge the pattern 125% before cutting. Cut out the foot of the bowl and save it to use as a shield to shade underneath for background. The spaces between the dark purple grapes on the right are to be filled in after they are stenciled by using a soft circular motion with only a little paint on the brush.

Colors to be used:

White—use on all the peaches and grapes.

Yellow—cadmium yellow medium. Use on the fruit, including the peaches.

Rust—burnt sienna combined with cadmium yellow medium and white. Use on the grapes, cherries, and peaches.

Alizarin crimson—combined with burnt umber. Use on currants.

Green—yellow ochre combined with black and burnt sienna. Use on all the leaves and for fineline details.

Purple—Alizarin crimson combined with Prussian blue and burnt umber. Use on the grapes and plum.

Blue-gray—Prussian blue combined with Alizarin crimson and black and white. Use on the bowl.

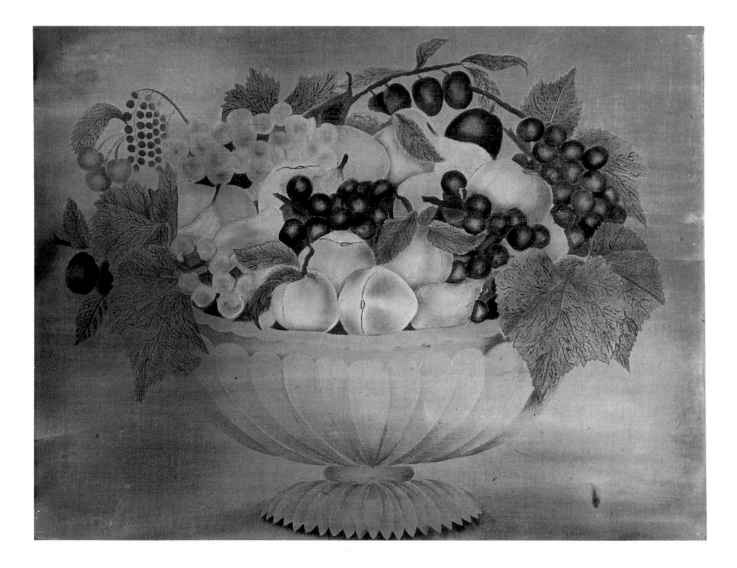

Two Roses with Buds

Note: This theorem on paper is from the collection of Helene Britt, H.S.E.A.D. The master pattern is full size. After painting in the base color of the leaves, leave the stencil in place and place a slightly curved piece of Mylar in position to create the central vein and stencil it in. Use another piece of Mylar on top of the central vein piece to create the side veins.

Colors to be used:

Red—Alizarin crimson combined with burnt umber. Use on the roses and buds.

Green—Prussian blue combined with cadmium yellow medium and black. Use on the leaves.

Burnt sienna—use on the tips of the leaves where appropriate.

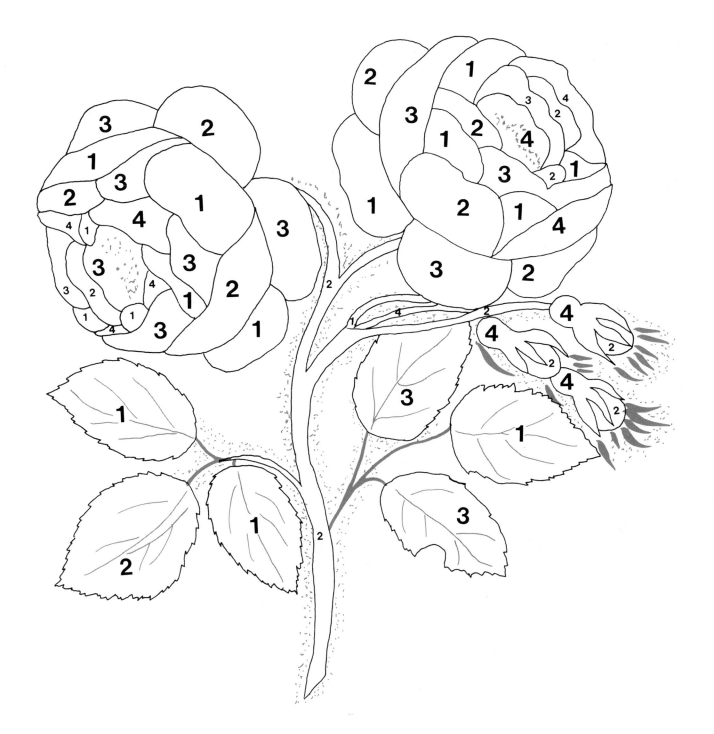

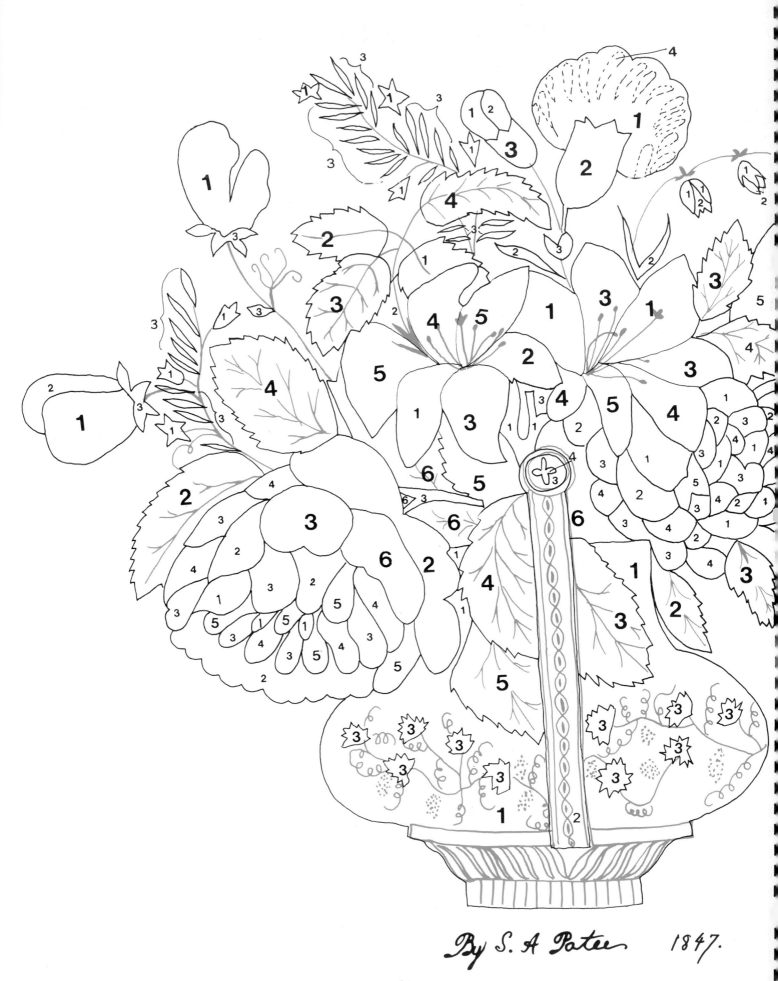

By S. A Patee 1847.

Pitcher of Flowers

Note: Signed S.A. Patee, 1847, this theorem on paper is from the collection of Phil Keegan, H.S.E.A.D. The master pattern is full size. Use Strathmore 400 drawing paper to make the theorem. After stenciling the leaves, leave the stencil in place and place a strip of slightly curved Mylar from leaf tip to stem and shade off on the appropriate side.

Colors to be used:

White—use on the buds at top center, the center lilies, and the fineline work on the tulip.

Light blue—white combined with a small amount of cerulean blue. Use lightly on the left side of the sweet pea blossoms and on the body of the pitcher.

Cadmium yellow medium—use on the tulip and on the handle of the pitcher.

Red—Alizarin crimson combined with burnt umber. Use over the yellow on the tulip, on the rose on the right; then add more white to the red and use on the rose on the left and on the rosebuds; also use for fineline details.

Green—cadmium yellow combined with Prussian blue and raw umber. Use on the leaves and stems.

Burnt sienna—use for floral decoration on body of the pitcher and for decorative detail on handle and base of pitcher.

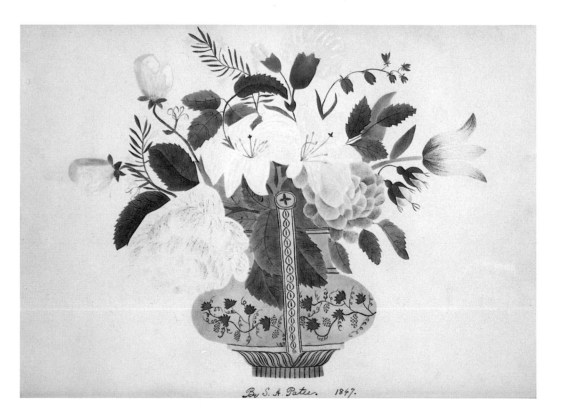

By S. A. Patee. 1847.

Bellpull

Note: This bellpull on velvet is believed to have been executed by Thomas Pardoe in England about 1820. It is from the collection of Willi McLean, H.S.E.A.D. The linear tracing is the actual size of the bellpull. However, the unit of 6 inches by 33¼ inches long is repeated several times to the desired length of the bellpull. Copy the pages of master patterns and tape them together to make a unit that is 6 inches by 33¼ inches in length. Cut the bellpull stencils on four long continuous stencils numbered 1, 2, 3, 4. We suggest that you cut your velvet 15 inches wide and to the desired length of the finished bellpull, then add 7 inches for finishing. The stencil motif should be centered on the width of the velvet. After the stenciling has been completed, place an iron-on fabric stiffener that is 6½ inches wide over the painted motif *on the wrong side* of the bellpull and press. Then, using the press cloth, fold the edges of the velvet over the fabric stiffener and turn the edges to finish the piece. Blind stitch the edges together on the wrong side.

Colors to be used:

Dark blue-green—Prussian blue combined with cadmium yellow medium and raw umber. Use on the leaves.

Raw sienna—use on the leaves along with the blue-green and on the morning glories and other blossoms.

Blue—Prussian blue combined with raw umber. Use on the morning glories, daisies, and primroses.

Naples yellow—use on the tulips and daisies.

Yellow ochre—use shaded over the Naples yellow on the tulips and daisies, and in the centers of various flowers.

White—use on the roses and the large white flower next to the roses.

Reds—Alizarin crimson combined with burnt umber. Use on the carnations, rosebuds, the peonies, and on the tulip petals.

Gray—black combined with white. Use on the large white blossoms next to the roses.

Section 1 Section 2 Section 3 Section 4

Pattern for section 1

Pattern for section 2

Pattern for section 3

99

Pattern for section 4

Basket of Flowers in Grisaille

Note: This exquisitely executed theorem on bristol board of old-fashioned flowers, fritillaria, guinea hens, primroses, and pinks is extremely unusual because it was executed totally in shades of gray, hence the term *grisaille*. It is from the collection of Mary Jane Clark, H.S.E.A.D. The master pattern is full size. This theorem could also be executed in color if it doesn't appeal in the original palette of grays.

Colors to be used:

The entire theorem should be executed in various shades of gray that should be mixed on your palette before beginning to paint.

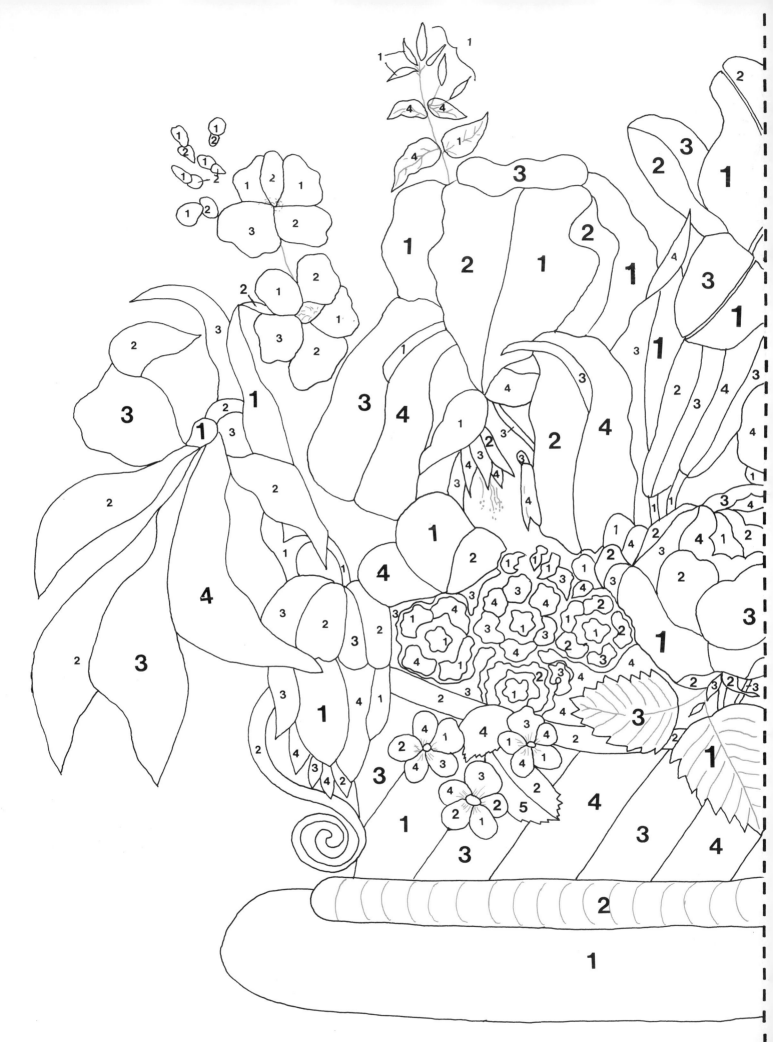

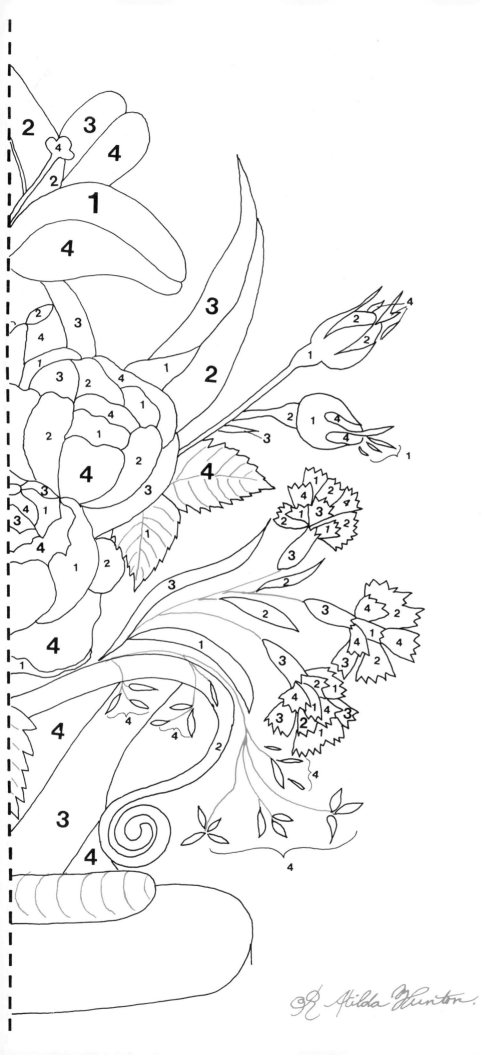

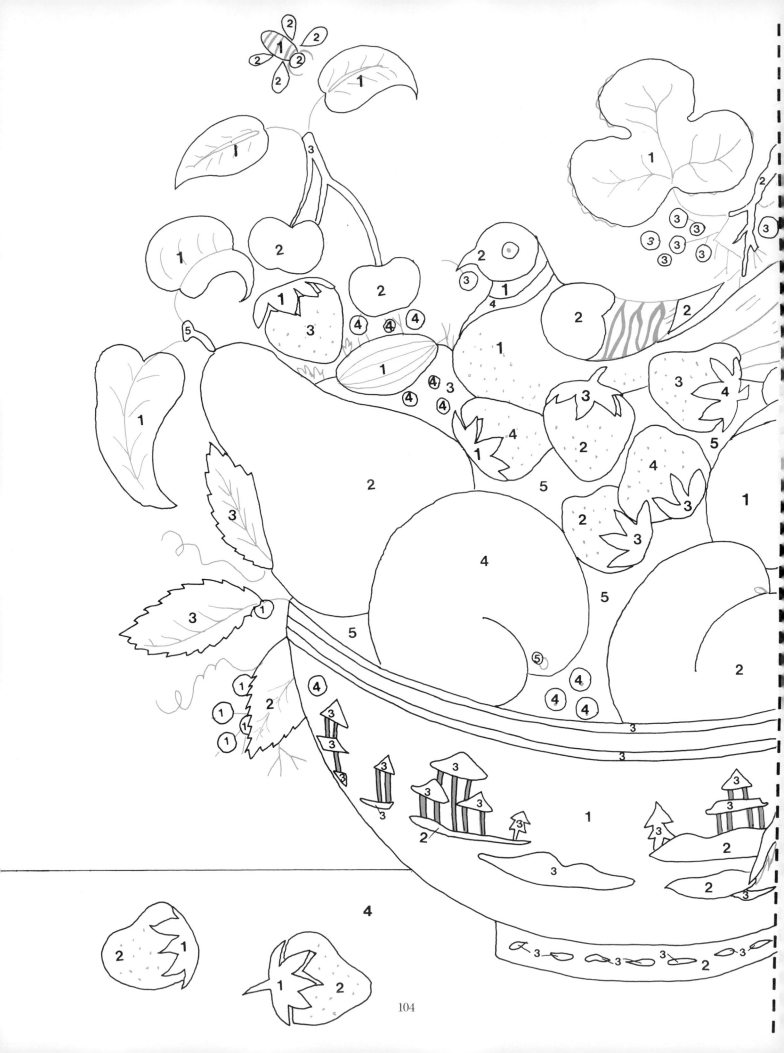

Chinese Bowl with Fruit and Bird

Note: This theorem on velvet by David Ellinger is from the collection of Ruth Flowers, H.S.E.A.D. The pattern is 92% of the original, so the pattern should be enlarged 108% before cutting. Save the pieces (blanks) you cut out for the bowl, berries, currants, apple, the bird's tail, and bird's eye. After the theorem has been completed use a large #6 stippling brush, and with a circular motion and with very little paint on the brush go over the grapes to create the blue-green background behind them. Be sure to hold the blanks in the appropriate areas for the bird's tail and the apple to shield these areas so that you can get good edges. Pouncing is a short, quick jabbing motion on the velvet of the stippling brush, which is loaded with paint.

Colors to be used:

Naples yellow—use on the fruit, the leaves, and the bee, and apply it thinly on the table.

Vermilion—use on the strawberries, berries, and cherries, and over the Naples yellow on the large fruit.

Burnt sienna—use this red-brown on the peaches, the pear, and on the large grape stem; this color should also be "pounced" (see explanation of "pouncing" above) on the table top.

Raw sienna—pounce on the table top.

Blue—Prussian blue combined with raw umber. Use for the decoration on the bowl and for the grapes.

Green—Prussian blue combined with cadmium yellow medium and raw umber. Use on the leaves and pounce on the table top.

Burnt umber—use on the bowl, the bird, the shading on the table top under the bowl and strawberries, and behind the veining on the large leaves, and for fineline details (tendrils, veins, seeds, etc.).

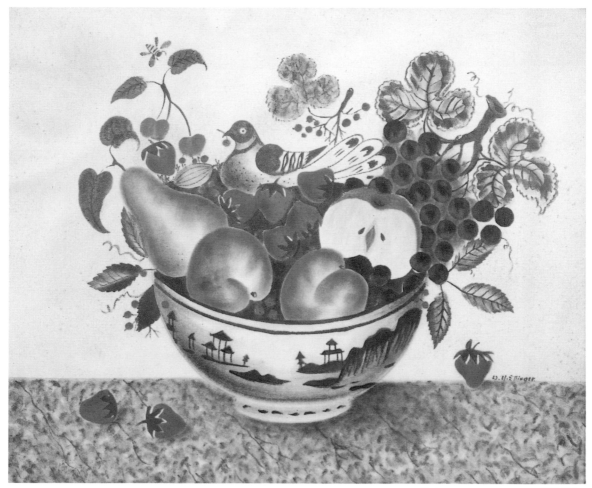

Pattern appears on pages 104-105.

Velvet Trinket Box with Passepartout

Note: This velvet trinket box is from the collection of Sally Lovely, H.S.E.A.D. The master pattern is full size. The velvet theorem is applied to the top of the box and is edged with passepartout (gold paper tape).

Colors to be used:

Naples yellow—use on all the fruit.

Red—cadmium red medium combined with vermilion. Shade on the fruit over the yellow base.

Green—Prussian blue combined with cadmium yellow medium and burnt sienna. Use on the leaves.

Burnt umber—use for fineline details.

Thread Box

Note: This thread box with a top made with a velvet theorem edged with passepartout (gold paper tape) is from the collection of Mary Sanford, H.S.E.A.D. The master pattern is full size. Velvet and paper theorems make attractive tops for boxes. The theorems can be glued down to the top's surface with a contact spray mount. Edges can then be brightened by covering them with passepartout, if desired.

Colors to be used:

Naples yellow—use on the flowers as the base color.

Red—cadmium red medium combined with vermilion. Use as shading on the yellow.

Green—Prussian blue combined with cadmium yellow medium and raw umber. Use on the leaves.

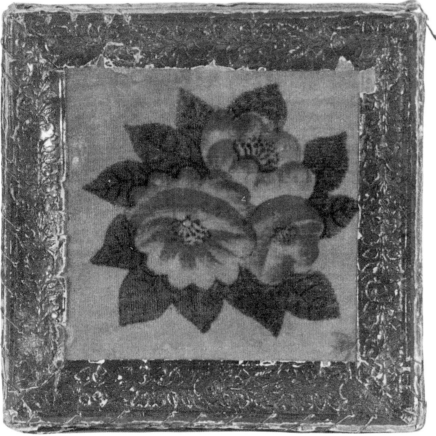

Single Rose with Buds

Note: This theorem on paper, which is probably an illustration from a seed catalog, is from the collection of Ruth Flowers, H.S.E.A.D. The master pattern is full size. Use Strathmore 400 drawing paper. Cut the entire outside edge of the rose and the buds on a piece of Mylar (see the dotted lines on the master pattern) and then color the entire blossom with a light coat of Indian red combined with vermilion and white, then proceed with stencil #1. To execute the leaves, complete the leaf unit and leave the stencil in place. Lay a straight edge of Mylar for the central vein and deepen the color. Lay a second straight edge at an angle to do the smaller veins.

Colors to be used:

Green—Prussian blue combined with cadmium yellow medium and black and raw umber. Use for the leaves and stems.

Red—Indian red combined with vermilion and white. Use for the rose, the buds, and for fineline details on the rose and buds.

Brown—burnt sienna combined with burnt umber. Use for the thorns.

Floral Polescreen

Note: This handsome velvet theorem is from the collection of Linda Lefko, H.S.E.A.D. The master pattern has been reduced by 10% to fit the book, so it is necessary to enlarge the pattern to 110% before cutting.

Colors to be used:

Light blue—cerulean blue combined with Prussian blue and white. Use under the top center rose, on the two open blossoms on the right, and on the thorns.

Bright blue—cerulean blue combined with Prussian blue. Use on the small leaves, rose sepals, the back of the large flower on the left, and the centers of the two flowers on the right.

Dark blue—Prussian blue combined with black and raw umber. Use over the light blue on the top center rose, on the two open blossoms on the right and on the bud cup on the right.

White—white combined with a touch of Prussian blue and black. Use on the roses and begonia.

Raw sienna—use on the leaf tips.

Burnt umber—use for shading on the begonia units.

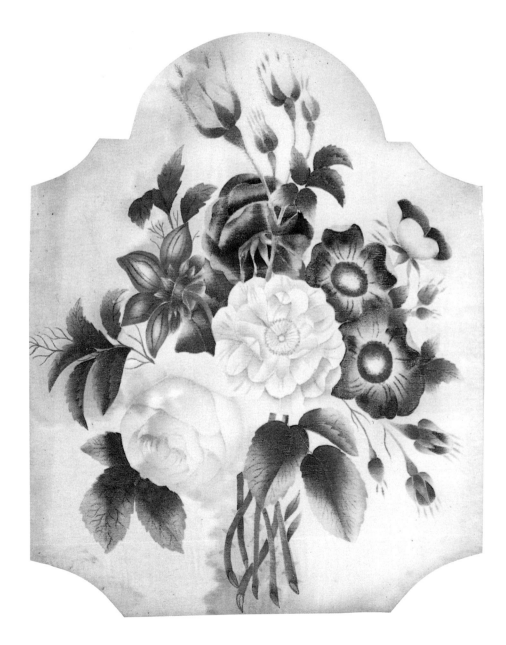

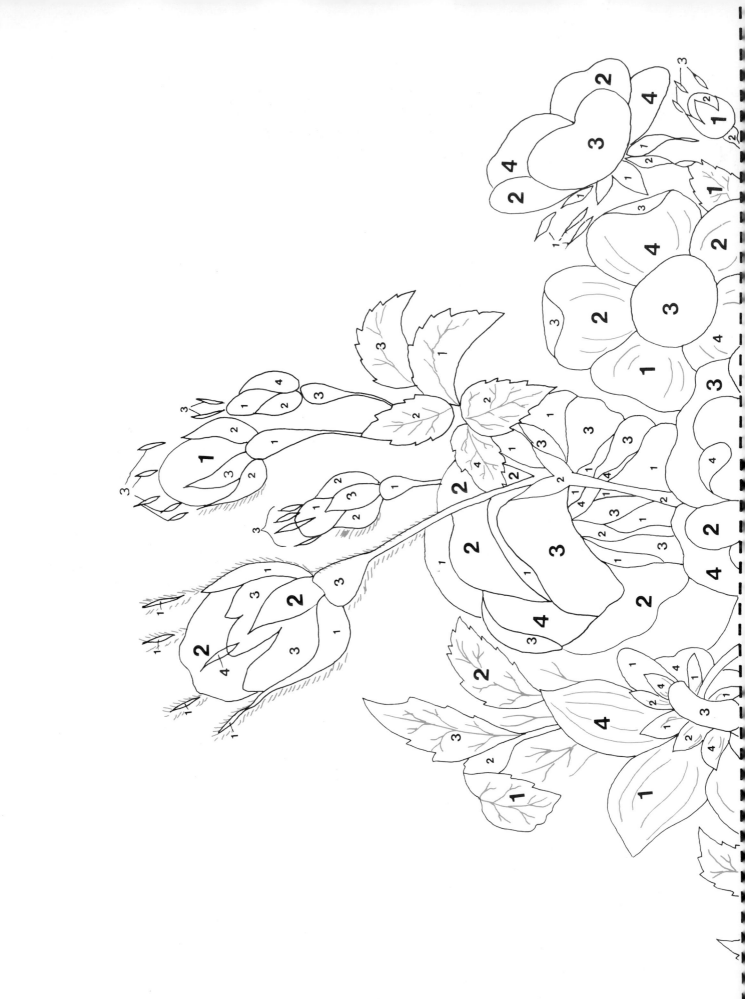

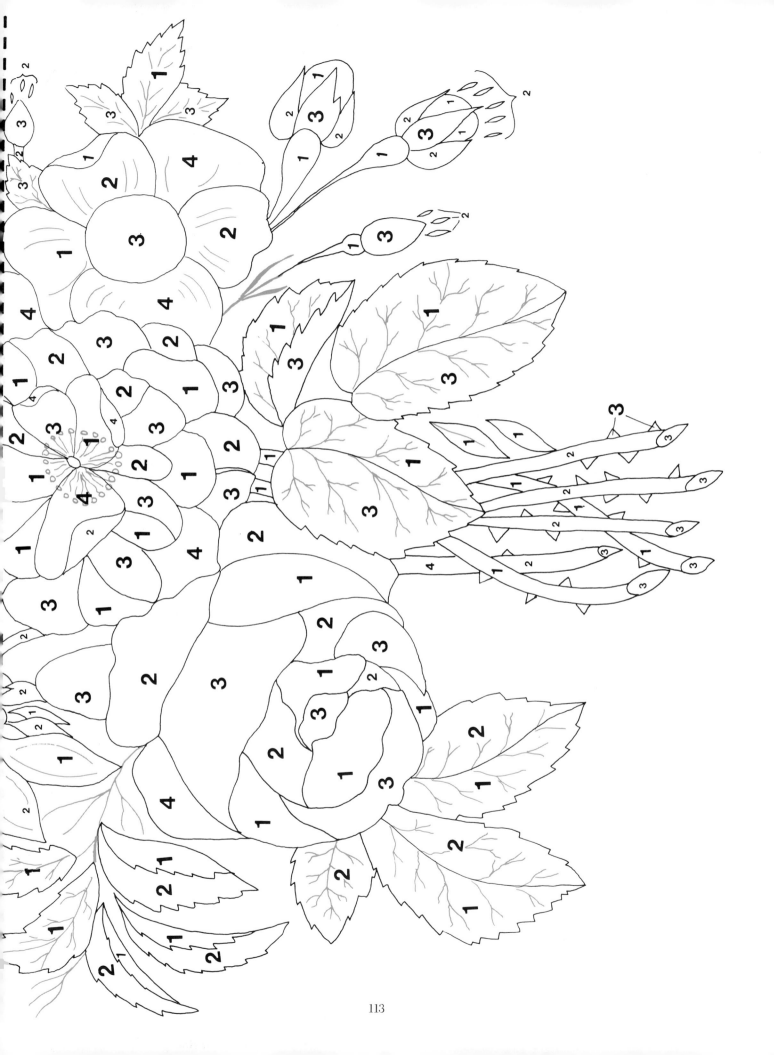

Doves on a Branch

Note: This charming theorem on paper is from the collection of Ruth Flowers, H.S.E.A.D. Use Strathmore 400 drawing paper. The pattern has been reduced by 13% to fit this book, so enlarge the pattern by 113% before cutting. After stenciling the wing unit, cut a slight curve from Mylar and lay it over the wing stencil and stencil the shading of the feathers.

Colors to be used:

White—use as the base color for the doves.

Gray—black combined with white. Use for shading the feathers on the doves.

Yellow—cadmium yellow medium. Use on the beaks.

Brown—burnt sienna combined with burnt umber shading. Use on the branch.

Reddish brown—burnt sienna combined with yellow ochre. Use on the feet.

Dark green—yellow ochre combined with black and Prussian blue and burnt sienna. Use on the foliage.

Light green—dark green combined with white. Use on the foliage.

Yellow—yellow ochre. Use on the foliage.

Vermilion—use for fineline detail on the beaks.

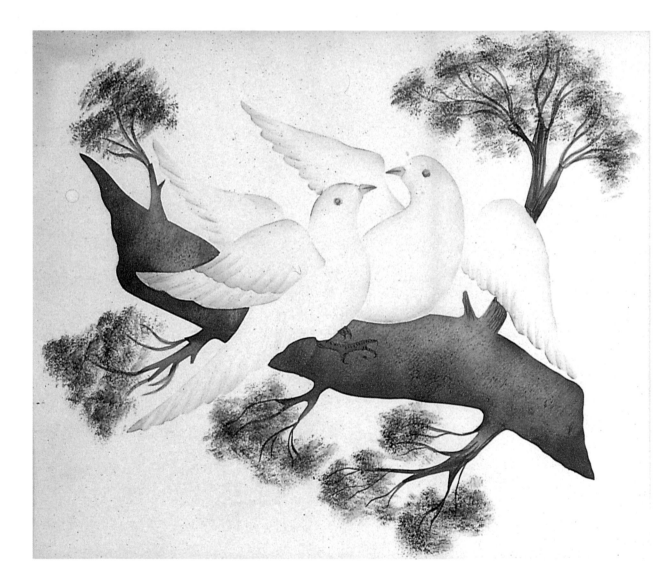

114

117

Bird Plucking a Strawberry from a Basket of Fruit

Note: This velvet painting from the collection of Barbara Knickerbocker, H.S.E.A.D., was probably not stenciled, but it can be rendered very satisfactorily with stencils. The pattern was reduced by 13% to fit the book, so enlarge the pattern by 113% before cutting. Cut out a circle for the bird's eye and hold it in place as a shield while painting the bird's head. Save the units cut from the bird's tail and use them as a shield when painting dark green.

Colors to be used:

Naples yellow—use on the butterfly, on the fruit, on the edges of leaves, and on the bird's tail.

Green—cadmium yellow medium combined with Prussian blue and black. Use on the bird's breast and tail, on the leaves and strawberry hulls.

Burnt sienna—use on the cherries and currants, on the strawberries and grapes, and on the stems, the basket, and for fineline details.

Burnt sienna combined with white—use on the strawberries and other fruit.

Burnt umber—shade over the grapes and also use for fineline details.

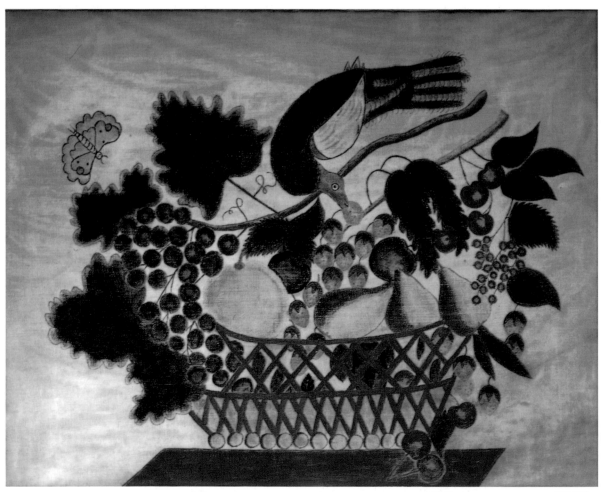

Pattern appears on pages 116-117.

Blue Urn with Satyr's Head

Note: This unusually handsome velvet painting is from the collection of Mary Sanford, H.S.E.A.D. Much of the original painting was probably done freehand, but the stencils have been designed to give results that will be close to the original. The pattern was reduced by 13% to fit the book, so enlarge the pattern 113% before cutting.

Colors to be used:

Bright blue—cerulean blue combined with white. Use on the flowers and buds where appropriate.

Dark blue—Prussian blue combined with black. Use on the remaining blue areas, on the urn and pedestal, and for most of the fineline details.

Gray—use on the urn and the leaves.

Yellow ochre—use on a few flowers and buds.

White—use for the rose and on other large and small flowers where appropriate.

Red—Alizarin crimson combined with burnt umber. Use over the white base on the rose.

Brown—burnt umber. Use on the urn, flowers, and leaves.

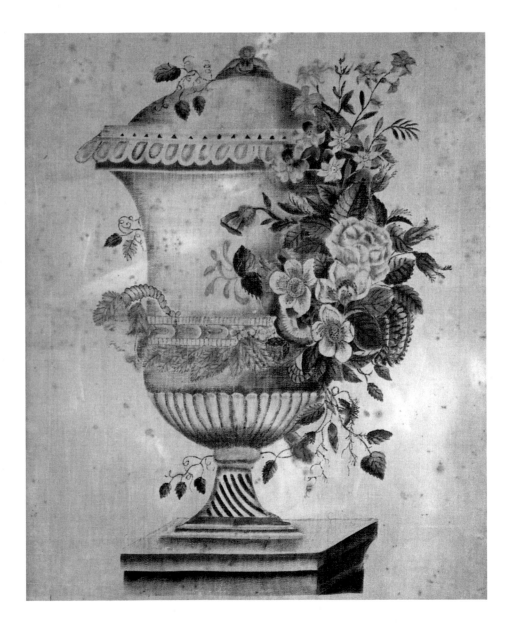

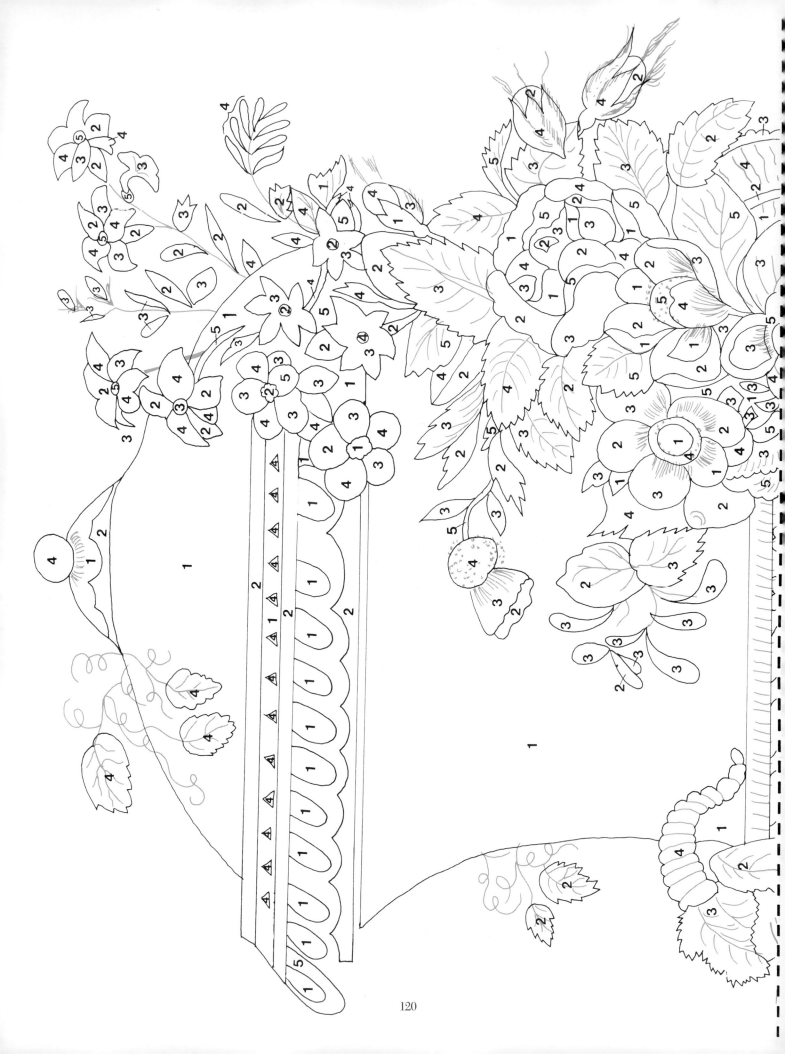

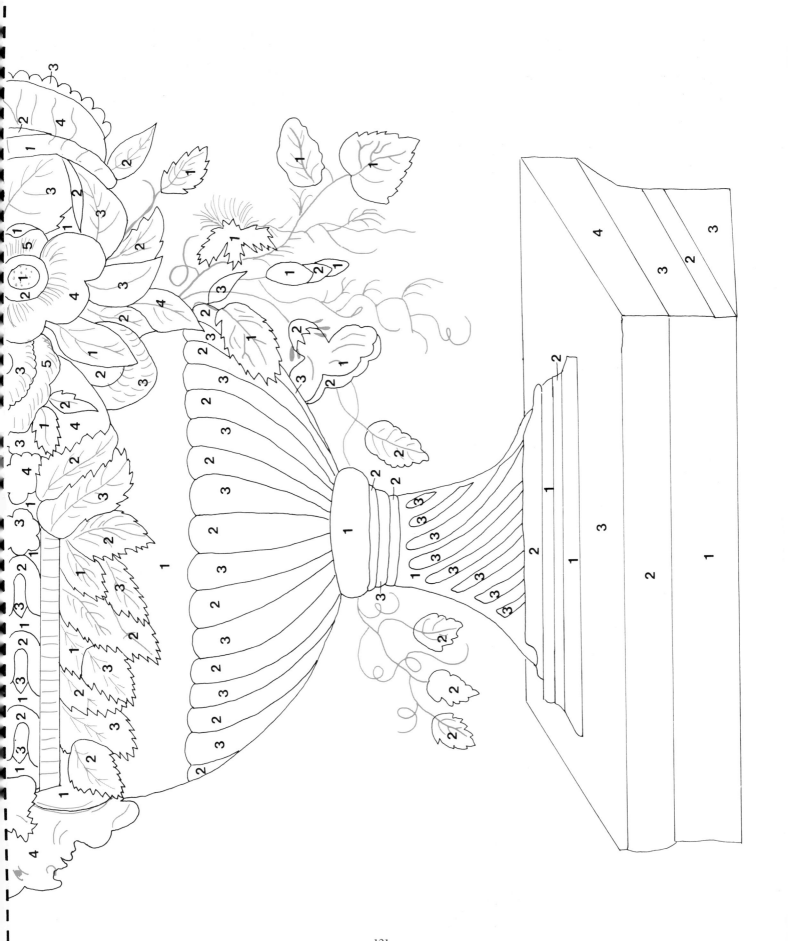

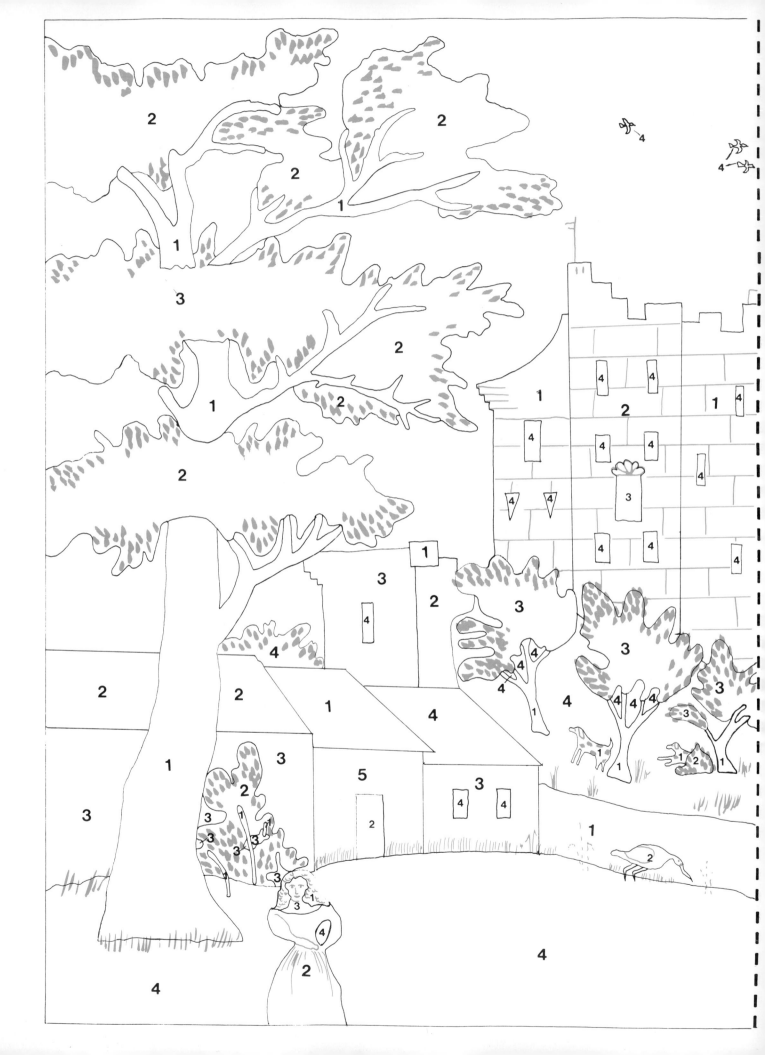

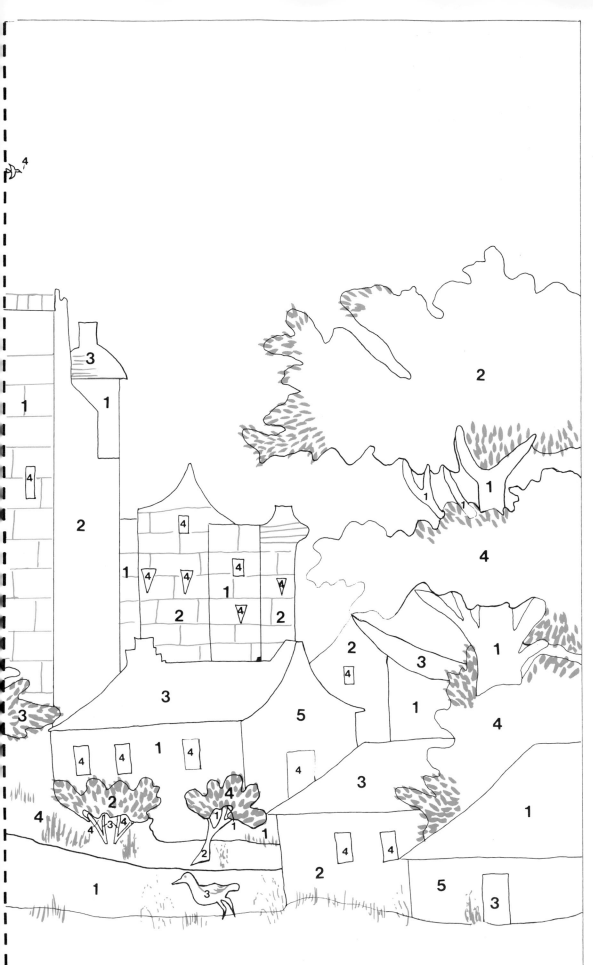

Stencil for the water reeds

Castle and Village with Girl and Geese

Note: This unusual scenic stencil painting is from the collection of Sally Lovely, H.S.E.A.D. The pattern has been reduced by 44% to fit the book, so enlarge the pattern by 144% before cutting. Cut the small unit depicting water reeds on a separate stencil and use it at the appropriate places on the theorem.

Colors to be used:

Blue—Prussian blue combined with black and white. Use in the sky and stream.

Green—Prussian blue combined with cadmium yellow medium and burnt sienna. Use for the grass and foliage and for detail work on the grass and trees.

Brown—burnt umber. Use for the castle and houses, the tree trunks, birds in the sky, the girl's hair, and for detail work on the building.

Raw umber—use for geese and use yellow ochre for their beaks.

Flesh color—burnt sienna combined with white. Use on the girl.

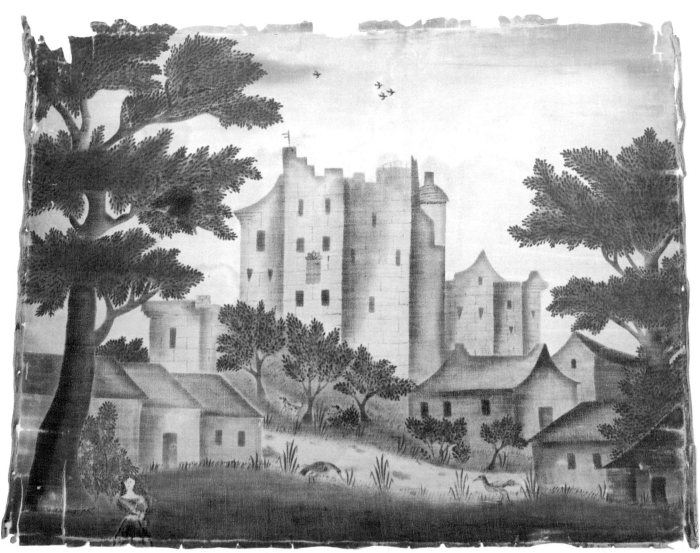

Pattern appears on pages 122-123.

Bird with Geranium Leaves

Note: This theorem on paper is from the collection of Jean Milonas, H.S.E.A.D. Use Strathmore 400 drawing paper. The master pattern is full size. After the green is stenciled on the leaves, leave the stencil in place and lay a straight edge of Mylar along the dotted lines of the master pattern and stencil again with dark green to set in the veins on the leaves.

Colors to be used:

Light green—Prussian blue combined with cadmium yellow medium, raw umber, and black. Use for the leaves and large stems.

Dark green—add more black to the light green color above. Use for the veins in the leaves.

Red—Alizarin crimson combined with burnt umber and black. Use on the bird's breast, the flowers, and buds.

Black—use on the bird's wings and feet, and for fineline details on the leaves.

Gray—use on the bird's head, neck, and tail.

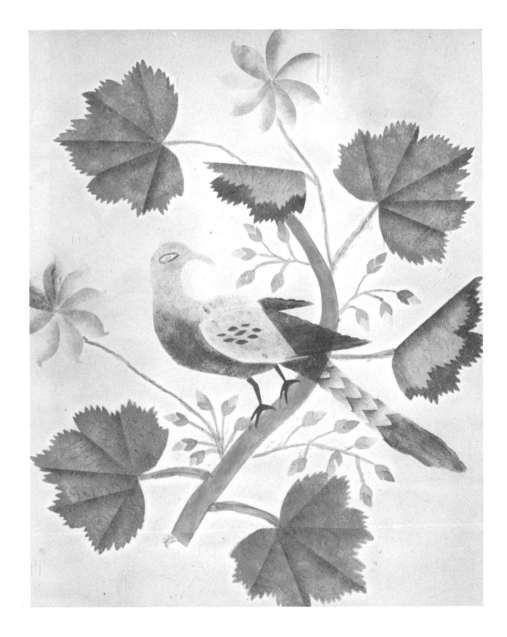

Bibliography

This selected bibliography lists the books and periodicals that were used in the preparation of this work. It is intended to provide the reader with a resource for further research and study.

Old Books

Alston, J.W. *Hints to Young Practitioners, in the Study of Landscape Painting to Which are Added Instructions in the Art of Painting on Velvet.* London: 1805.

Bohn, Henry G. *The Young Ladies Book, a Manual of Elegant Recreations, Arts, Sciences.* London: 1859.

Child, L. Maria. *The Girl's Own Book.* New York: Clark Austin, 1833.

Finn, Matthew D. *Theorematical System of Painting.* New York: James Ryan, 1830.

Gandee, B.F. *The Artist or Young Ladies Instructor in Ornamental Painting, Drawing, etc.* New York: 1835.

MacKenzie, Colin. *Five Thousand Receipts in All the Useful and Domestic Arts Constituting a Complete and Universal Practical Library and Operative Encyclopedia.* Philadelphia: 1825 and 1852.

Niles, Eva M. *Fancy Work Recreations.* Buckeye, 1885.

Porter, Rufus. *A Select Collection of Valuable and Curious Arts and Interesting Experiments Which Are Explained and Warranted Genuine and May Be Performed Easily, Safely and At Little Expense*, Third Ed. Concord, New Hampshire: J.B. Moore, Printers, 1826.

Slack, J. *A New Universal Drawing Book and General Instructor for Mixing and Compounding Colours.* (n.d.)

Tilton, J.E. & Co. *Art Recreations.* Boston: 1860.

———*The Young Ladies Journal*, Complete Guide to the Worktable. London: 1885.

Turner, Maria. *Young Ladies Assistant in Drawing & Painting.* Cincinnati, Ohio: Corey & Fairbank, 1833.

Whittock, Nathaniel. *The Art of Drawing and Coloring from Nature, Flowers, Fruits and Shells. Correct Directions for Preparing Most Brilliant Colors for Painting on Velvet with the Mode of Using Them.* London: I.T. Hinton, 1829.

New Books

Butler, Anna C. *Procedures in the Various Techniques of Painting on Velvet—Theorem Method.* Great Barrington, Massachusetts: Berkshire Courier Press, 1966.

Craig, James H. *The Arts and Crafts in North Carolina 1699–1840*, Winston-Salem, North Carolina: Museum of Early Southern Decorative Arts, Old Salem, Inc., 1965.

Drepperd, Carl W. *American Pioneer Arts & Artists.* Springfield, Massachusetts: Pond-Ekberg, 1942.

Ebert, John and Katherine. *American Folk Painters.* New York: Charles Scribner's Sons, 1975.

Ford, Alice. *Pictorial Folk Art: New England to California.* New York: Studio Publications, 1977.

Lipman, Jean. *American Primitive Painting.* Oxford University Press, 1942. New York: Dover Publications, 1972.

———. *Rufus Porter Rediscovered.* New York: Clarkson N. Potter, 1968, 1980.

Lipman, Jean and Alice Winchester. *The Flowering of American Folk Art, 1776–1876.* New York: Viking, 1974.

Little, Nina Fletcher. *Abby Aldrich Rockefeller Folk Art Collection Catalogue.* Boston: Little, Brown, 1957.

———. *Country Art in New England 1790–1840.* Sturbridge, Massachusetts: Old Sturbridge Village, 1960.

McClinton, Katherine Morrison. *Antique Collecting for Everyone.* McGraw-Hill, 1951.

Pettit, Florence H. *American Printed and Painted Textiles.* New York: Macmillan, 1950.

———. *Whirligigs and Whimmy Diddles and Other American Folkcraft Objects.* New York: Thomas Y. Crowell Co., 1972.

Slayton, Mariette Paine. *Early American Decorating Techniques.* New York: Macmillan, 1972.

Van Ravenswaay, Charles. *A Nineteenth-Century Garden.* New York: Universe Books, 1977.

Waring, Janet. *Early American Stencils on Walls and Furniture.* New York: Dover, 1968.

Periodicals

Cobb, Margaret E. "Rice Paper Paintings: "Trivialities of the China Trade," The Magazine *Antiques* (March 1956), 246–7.

Drepperd, Carl W. "Still Life and Pretty Pieces," *Art in America* (May 1954), 126, 132.

Francis, Henry S. "Water Colors Made By the 'Theorem Method' and Drawings," *Bulletin of the Cleveland Museum of Art* (October 1934), 128–31.

Furnari, Dolores. "A New Look at Theorem Painting," *Decorative Artist's Workbook* (February 1990), 50–55.

Giffen, Jane C. "Susanna Rowson and her Academy," The Magazine *Antiques* (September 1970), 436–40.

Greenhill, Ruth Ann. "A Treatise on 19th Century Theorem Painting as Practiced Today," *The Decorative Sampler Series*, Booklet I, 1979.

Hale, Sarah J. and Louis A. Godey (editors). *The Lady's Book* (1831), 308 and 149–50. *Godey's Lady's Book* (1854), 393–95.

Hampton, Maddie. "Velvet Painting," *The Decorator* (Fall 1965), 8–10.

Holz, Loretta. "Valentine Memories," *Creative Crafts* (February 1973), 39–49.

Hopf, Claudia. "Velvet Painting," *The Spinning Wheel* (July/August 1970), 456–58.

Karr, Louise. "Painting on Velvet," The Magazine *Antiques* (September 1931), 162–65.

Levine, Carol. "The Art of Painting on Velvet," *Early American Life* (August 1973), 53–57.

McIntyre, Vickie. "Theorem Paintings," *Early American Life* (August 1981), 28–29, 62–69.

Peck, Grace Brownell. "Amateur Art in Early New England," *Harper's Magazine* (May 1902), 987–994.

Piwonka, Ruth and Roderick H. Blackburn. "New Discoveries About Emma J. Cady," The Magazine *Antiques*, 418–21.

Ring, Betty. "Memorial Embroideries by American Schoolgirls," The Magazine *Antiques* (October 1971), 570–75.

Rivera, Betty. "The Theorem as Art," *The Antiques Journal* (October 1970), 24–25.

Rumford, Beatrix. "Memorial Watercolors," The Magazine *Antiques* (October 1973), 688–95.

Smith, Linda Joan. "Parlor Paintings Past and Present," *Country Home* (October 1990), 108–114.

Sparrow, Walter Shaw. "Charlestown of London (1781–1854) and the Town Painters on Velvet," *The Connoisseur* (August 1931).

Stein, Aaron Marc. "The Still Life in American 'Primitive' Art," *The Fine Arts* (June 1932), 14–17, 42, 43.

Stow, Charles Messer. "Primitive Art in America," *The Antiquarian* (May 1927), 20–25.

Underhill. Emilie. "Old Theorems Come to Light," *The Decorator* (Spring 1959), 11–13.